WOMEN AND THE SPIRIT OF THE NEW DEAL

NATIONAL NEW DEAL PRESERVATION ASSOCIATION

FRANCES PERKINS CENTER

LIVING NEW DEAL

ISBN 978-0-578-43707-1
Library of Congress Control Number: 2019902179
BISAC: HIS058000 History/ Women
 HIS036060 History/United States/20th Century
 ART065000 Art/ Women artists
Printed in the United States of America

This work was designed, produced, and published in the United States of America by
 National New Deal Preservation Association
 Kathryn Flynn, Executive Director
 PO Box 602
 Santa Fe, New Mexico 87504
 1-505-473-3985

Website: www.newdeallegacy.org
 E-mail: newdeal@cybermesa.com

The authors and publisher welcome comments and corrections, at the above e-mail address, in regard to th documentation in this work.

The views expressed are solely those of the authors. Any errors or omissions in this book are not intention and are the responsibility of the authors.

INTRODUCTION

In this book we highlight the extensive roles of women in the programs and operations of the New Deal under President Franklin D. Roosevelt. Some of the women included were highly visible to the public and to history while others were behind the scenes and have been virtually forgotten. Some were prominent during the period 1933 to 1945 while not formally linked to government programs. Most played significant roles in the numerous agencies, projects and programs of the Federal Government during these years, a period of little more than a decade when the relationship between the government and the citizen was profoundly reshaped.

This book begins a process of identifying hundreds if not thousands of women whose roles during this eventful period were of consequence in contributing to the transformations that took place through the initiatives of the Roosevelt Administration. Our hope is that readers of this book will contribute the names and descriptions of additional women (including modifications and/or elaborations of the biographies contained herein) to the websites of the three sponsoring organizations where they will be available to students, scholars and interested citizens:

National New Deal Preservation Association: www.newdealegacy.org
Frances Perkins Center: www.francesperkinscenter.org
Living New Deal: www.livingnewdeal.org

Towards the back of the book is a list of women for whom we only have limited information beyond their titles. Please see if any of these women might have been connected to your family or to you in other ways that would allow you to contribute information on them to this "discovery" project. You can send information to Kathy Flynn at the National New Deal Preservation Association.

The book was originally compiled for a conference in Berkeley, California on October 5-6, 2018, jointly sponsored by the three organizations and entitled "Women and the Spirit of the New Deal." Its collective authorship includes Christopher Breiseth, Kathryn Flynn, Kathleen Duxbury, Harvey Smith, T.J. Walker and LND president Gray Brechin, with significant technical assistance from NNDPA members Elizabeth Kingman and Kathleen Duxbury. Its publication was made possible by the generous support of the following "New Deal Addicts" and Friends:

Walter Atwood
Christopher Breiseth
David Douglas
Kathleen Duxbury
Kathryn Flynn

Vicky Jacobson
Michael Keleher
Kovler Family Foundation
David Lembeck
Sims McCutchen
Joseph Plaud

Ellen Premack
James Rowe III
Michael Ticktin
Thomas J. Walker
Herta Wittgenstein

The following women played important roles in government, politics, and the law. Many were associated with the arts, under the auspices of New Deal programs and projects. Their names will appear here and on the websites of the three sponsoring organizations: the **Living New Deal,** the **National New Deal Preservation Association,** and the **Frances Perkins Center.**

NEW DEAL

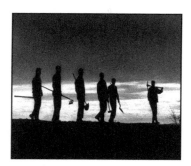

Civilian Conservation Corps
(1933 - 1942) NACP

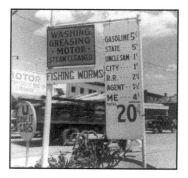

Gas Price Breakdown
by Dorothea Lange FSA/LOC

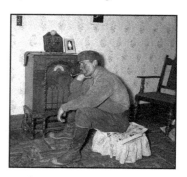

Radio Listener, Westover, W.V.
Marion Post Wolcott FSA/LOC

Buffalo, New York. NYA, train-
ees between the ages of seven-
teen and twenty-one learning
to use lathes in preparation for
jobs in the war industry. LOC

1933 Agricultural Adjustment Administration (AAA)
 Civilian Conservation Corps (CCC)
 Civil Works Administration (CWA)
 Economy Act
 Emergency Banking Act
 Emergency Farm Mortgage Act
 Farm Credit Administration (FCA)
 Federal Deposit Insurance Corporation (FDIC)
 Federal Emergency Relief Act (FERA)
 Historical American Buildings Survey (HABS)
 Home Owners Loan Corporation (HOLC)
 National Industrial Recovery Act (NIRA)
 National Labor Board (NLA)
 National Recovery Administration (NRA)
 National Youth Administration (NYA)
 Public Works Administration (PWA)
 Public Works of Art Project (PWAP) – including CCC Art
 Tennessee Valley Authority (TVA)
 Truth-in-Securities Act

1934 Federal Communications Commission (FCC)
 Indian Reorganization Act
 National Housing Act
 National Labor Relations Board (NLRB)
 Securities and Exchange Commission (SEC)
 Treasury Section of Painting and Sculpture (Section) –
 including CCC Art Project

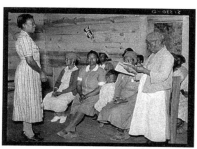

Left: Juanita Coleman, a teacher and
NYA (National Youth Administration)
leader, listening to one of her pupils,
eighty two years old and best in class,
who has learned to read. Gee's Bend,
Alabama. LOC

PROGRAMS

1935 Emergency Relief Appropriation Act.
Indian New Deal Administration (INDA)
Rural Electrification Administration (REA)
Resettlement Administration (RA)
Social Security Board (SSB)
Soil Conservation Service (SCS)
Treasury Relief Art Project (TRAP)
Wagner Act
Works Progress Administration (WPA)

 a. Federal Art Project (FAP)
 b. Federal Dance Project (FDP)
 c. Federal Music Project (FMP)
 d. Federal Theater Project (FTP)
 e. Federal Writers Project (FWP)
 f. Historical Records Survey (HRS)

1936 U.S. Maritime Commission
Works Progress Administration changed to Works Projects
Administration – Still referenced as WPA

1937 Farm Security Administration (FSA)
Bankhead Jones Act

1938 Fair Labor Standards Act

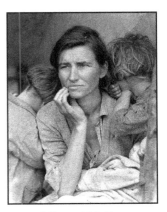

Migrant Mother
by Dorothea Lange FSA/
LOC

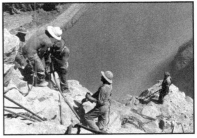

High Drillers - Boulder Dam -PWA
LOC

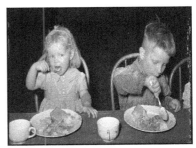

May 1940, Children eating lunch,
Agua Fria migratory labor camp
WPA nursery school, Arizona,
photographer Russell Lee, LOC

Left: *Jackhammer Operator*, TVA Douglas
Dam, Tennessee. LOC

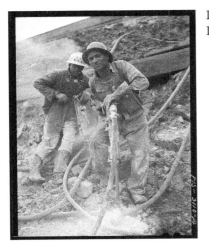

Right: May 1936 - Harry Hopkins,
Director of the WPA (2nd from left)
stands next to Hallie Flanagan, Direc-
tor of the FTP, in the dressing room of
the NYC Experimental Theatre with
FTP actors. NACP

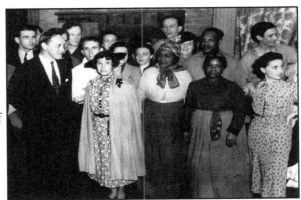

TABLE OF CONTENTS

MAJOR WOMEN LEADERS
IN GOVERNMENT, POLITICS AND THE LAW

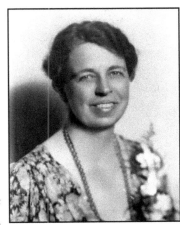

LOC

ELEANOR ROOSEVELT

The foremost member of the women's New Deal network in the 1930s. Her institutional role as First Lady, her willingness to use her public position to push for reform, and her ability to inspire loyalty in friends and colleagues, placed her "at the center of this growing New Deal political sisterhood." It is difficult to imagine the progress that occurred for women in the 1930's without Eleanor Roosevelt in the White House. Susan Ware, *Beyond Suffrage Women in the New Deal* (Harvard University Press, 1981), p. 7. Because of Eleanor Roosevelt's critical advocacy of New Deal art projects (with her friend Elinor Morgenthau), artist Lucien Labaudt painted her at the center of a group of male art administrators in his mural of San Francisco city life in Coit Tower. See also, Blanche Wiesen Cook, *Eleanor Roosevelt, Volume 2, 1933-1938* (Viking, 1999).

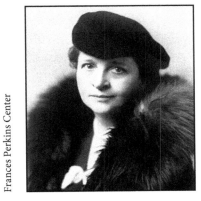

Frances Perkins Center

FRANCES PERKINS

"Behind the passage of some of the New Deal's most important social legislation stood Frances Perkins….The Committee on Economic Security, composed of the Secretaries of Labor, Agriculture, and the Treasury, the Attorney General, and Harry Hopkins of the Federal Emergency Relief Administration, was established in June of 1934. Its mandate was to draft a comprehensive social security program, including both unemployment and old age insurance, for presentation to the President by December, 1934. An important consideration was drafting the law in a form likely to win constitutional approval from the Supreme Court. Frances Perkins headed this committee at President Roosevelt's personal insistence. 'You care about this thing. You believe in it. Therefore I know you will put your back into it more than anybody else, and you will drive it through. You will see that something comes out, and we must not delay.'" Ware, pp. 96-7 See also, Kirstin Downey, *The Woman Behind the New Deal: The Life and Legacy of Frances Perkins—Social Security, Unemployment Insurance, and the Minimum Wage* (Nan A. Talese: Doubleday, 2009).

FLORENCE ALLEN

"One final appointment that [Molly] Dewson arranged was that of Florence Allen, then of the Ohio Supreme Court, to the United States Court of Appeal for the Sixth Circuit in 1934. Both in importance (a 'first' for women, and the highest women had risen in the federal judiciary) and in its timing and tactics, the campaign for Allen bore a remarkable similarity to that behind Frances Perkins for Secretary of Labor…. Dewson needed no introduction to Allen… for they had first met at a national suffrage convention in Washington in 1914. Dewson and [Emily Newell] Blair, together with Franklin Roosevelt, Eleanor Roosevelt, Louis Howe, Mary Anderson, and many other women associated with the network, gathered support for Allen's nomination. Continuous pressure, both in Washington and in Ohio, finally paid off and the appointment went through." Ware, pp. 55-56.

LOC, George Grantham Bain collection

MARY ANDERSON BAIN

"Mary Anderson Bain… was an idealistic young liberal when she launched her public service career in Illinois in the mid-1930s. She was among the few women hired as managers by a New Deal program called the National Youth Administration (NYA), and, at 28, she was one of the agency's youngest state administrators. Another was a Texan named Lyndon Johnson. She ended her public service career in Washington more than 60 years and 11 presidents later, still an unreconstructed New Dealer. She was perhaps best known as the long-serving chief of staff to U.S. Representative Sidney R. Yates (D-ILL)….one of the first women on Capitol Hill to serve as a chief of a Congressional staff. From 1975-1995, when Yates was chairman of the appropriations subcommittee that funded the arts and the humanities, she was deeply involved in efforts to preserve the nation's cultural heritage….and was fiercely protective of the National Endowment for the Arts during the so-called culture wars of the 1980's and 1990's." "I'm a liberal," she told the New York Times at the 1997 dedication of the national memorial to her hero, Franklin D. Roosevelt. "Born one; die one." (Obituary by Joe Holley, *Washington Post*, August 11, 2006.)

Chippewa Herald Telegram, Wi., 2/24/1940, newspapers.com

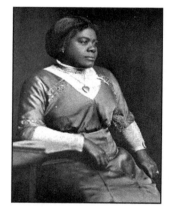

https://www.floridamemory.com/items/show/730

MARY MCLEOD BETHUNE

Born in 1875, the fifteenth of seventeen children to former slaves and growing up picking cotton, Bethune excelled in her education and started her own school for girls in Daytona, Florida which eventually merged with the Cookman Institute to form Bethune-Cookman College, focusing on "Self –control, Self-respect, Self-reliance and Race Pride." A suffragist, organizing voter registration drives throughout Florida in the 1920's, even in the face of the KKK, Bethune helped found the National Council of Negro Women, bringing 29 national organizations together. When Eleanor Roosevelt "suggested that she come to Washington in October 1934, Mary McLeod Bethune began a dazzling chapter in American politics. Originally one of thirty-five members of the National Advisory Committee of the new National Youth Administration created in 1935, she became director of Negro affairs for the NYA. The acknowledged leader of the unofficial Black Cabinet, which met each week in her home on Friday evenings to discuss priorities and strategies, she worked to forge the new activist civil rights movement." Cook, pp. 159-160.

MARY "MOLLY' DEWSON

In 1933 about thirty five women came into important positions in Washington, and in the last six or seven years there has been an increase in the number of women appointed to more important offices. Strange as it may seem, I think this is due to the work of [one] woman who never held any office, except that of Vice Chairman of the Democratic National Committee in charge of the Women's Division—Miss Molly Dewson …. I think virtually all the men from the President and Postmaster General Farley to most of the other heads of Departments, will concede that there has rarely been a woman more active in getting women into political positions!

SSA.gov

Eleanor Roosevelt, "Women in Politics," from the *Good Housekeeping Journal*, January, March, April, 1940, reprinted in *Courage in a Dangerous World: The Political Writings of Eleanor Roosevelt*, edited by Alida M. Black (Columbia University Press, 1999), p. 60-61. See also, Susan Ware, *Partner and I: Molly Dewson, Feminism, and New Deal Politics* (Yale University Press, 1989).

FLORENCE "DAISY" JAFFRAY HARRIMAN

An active socialite and suffragist, who ran the women's side of Woodrow Wilson's campaign in 1912. Daisy Harriman in the 1920's co-founded the Women's National Democratic Club and started her "Sunday Night Suppers" which became a Washington institution. In 1937 President Roosevelt appointed her Minister to Norway. An ordinary tour of duty was interrupted when seventy-year-old Harriman had to flee the Nazi invasion of Norway in April 1940. She helped get the Norwegian Royal Family to safety. Harriman returned safely to this country, lecturing and writing widely about her experiences in Norway. Ware, p. 147. She wrote two books, *From Pinafores to Politics* and *Mission to the North* about her experiences in Norway.

MARY T. NORTON

A Jersey City housewife when she entered politics in 1924, "Mary Norton became the first Democratic woman elected to Congress. During her tenure in Congress, she was Chairman of the District of Columbia Committee and after 1937, Chairman of the Labor Committee. From this powerful position, she played a large role in the passage of the 1938 Fair Labor Standards Act....Norton continued serving in Congress until her term expired in 1950." Ware, p. 150. Eleanor Roosevelt in her "My Day Column" on April 30, 1945, just two weeks after FDR's death, reported that "Representative Mary Norton of New Jersey is making a magnificent fight for the passage of the Fair Employment Practices bill. This bill would give us a permanent group in the government whose function it would be to see that, as far as employment goes throughout the country, there is complete equality of opportunity and treatment for all." Black, pp. 113-114.

CAROLINE O'DAY

A Congresswoman at-large from New York from 1935 to 1942. In 1935 "for the first time a First Lady actively participated in a political campaign. ER campaigned vigorously for Caroline O'Day....She ignored all opposition and [even] served as Caroline O'Day's finance chair. She was delighted to support a remarkable friend who had given so many years of her life to the women's movement and to social service, she said almost every day, in her speeches to large audiences throughout the state." Mrs. Roosevelt declared that "Mrs. O'Day represents in herself the real reason why most women enter politics, which is in order to achieve changes in our social organization which they become convinced can be reached only through government." Cook, pp. 221-222.

RUTH BRYAN OWEN

Daughter of William Jennings Bryan and a pioneer in the film industry. She was elected to Congress from the Fourth District in Florida in 1928 and again in 1930, being defeated in 1932 because of her pro-prohibition stand. "Her appointment as Minister to Denmark, a first for women, was unanimously confirmed by the Senate the same day it was submitted." She served from 1933 to 1936. Her third marriage, to a Captain in the Danish Royal Guards, created a potential complication of dual citizenship leading to her resignation in 1936 and a return to America. Ware, pp. 150-151.

JEANETTE RANKIN

First woman elected to Congress, one of the few suffragists elected to Congress, and the only Member of Congress to vote against U.S. participation in both World War I and World War II. Her speaking and organizing efforts helped Montana women gain the vote in 1914. At the time of her death in 1973, Rankin was considering another run for a House seat to protest the Vietnam War.

LOC

LOC

MARY HARRIMAN RUMSEY

Daughter of E.H. Harriman and sister of Averill Harriman, Mary Harriman Rumsey was the Chairman of the NRA's Consumers' Advisory Committee, 1933-1934, and Advisor on Consumer Affairs for the National Emergency Council during the same time.. Prior to her sudden death as a result of a fall from her horse in December 1934, Mary Rumsey shared her home with Frances Perkins and Perkins' daughter Susanna, serving as a key source of support for the new Secretary of Labor. After failing to get labor leader William Green and steel executives to talk with each other, even when in the same room, Perkins and Rumsey held a dinner party in their shared home including Green and his wife. During dinner, Mary took a phone call and extended an invitation to Myron Taylor of U.S. Steel to join them with his wife for dessert. "Green and Taylor were startled to see each other, but knowing they were in safe company, they soon drifted in each other's direction. When Frances next looked up, they were deep in conversation. Not long after, Taylor agreed to unionization, and soon after that, Roosevelt named him ambassador to the Vatican." Downey, pp. 164-165.

ROSE SCHNEIDERMAN

"There were three labor leaders whose careers [Frances Perkins] promoted by arranging for Roosevelt to nominate them to an NRA advisory board, convinced that they showed promise for the future. They were [John L.] Lewis, [Sidney] Hillman, and her old friend Rose Schneiderman, president of the Women's Trade Union League, the woman who had spoken out so angrily after the Triangle [Shirtwaist] Fire. In this way, Frances made sure the feisty immigrant who had felt she was unheard was now given a formal role in government." Kirstin Downey, pp. 202-203.

LOC

Expected to submit ideal NRA codes for industries where women predominated, Schneiderman regarded her Washington years as "the most exhilarating and inspiring of my life." In a recent *New York Times* article on Alexandra Ocasio-Cortez' Democratic primary victory in New York (July 22, 2018), Beverly Gage recalled that "It was around an I.W.W.–led textile strike in 1912 that the organizer Rose Schneiderman coined a lasting socialist slogan, declaring that 'the worker must have bread, but she must have roses too'—that working people deserved not just fat bellies but also beauty in their lives." *New York Times*, July 22, 2018, p.10.

ELLEN SULLIVAN WOODWARD

"More than anything else, however, Ellen Sullivan Woodward's dedication and talent shaped the government's relief policies towards women. Like Molly Dewson in the political arena and Frances Perkins in the social welfare field, Ellen Woodward, as head of the Women's and Professional Projects for the WPA, served as the network's main representative in promoting relief programs for women in the New Deal. And as did Dewson and Perkins, Ellen Woodward asked for and received help from her women friends in the network to accomplish her short-and long-term goals." Ware, pp. 105-106; Martha H. Swain, *Ellen S. Woodward: New Deal Advocate for Women* (University Press of Mississippi: Jackson, MS, 1995).

SSA.gov

SUPPORTIVE ROLES IN GOVERNMENT AND POLITICS

GRACE ABBOTT

Chief of the Children's Bureau, Department of Labor, from 1921 to 1934. Born in Nebraska in 1878 to a father active in politics and a mother who was an ardent abolitionist and early suffragist, Grace Abbott earned an M.A. in political science at the University of Chicago in 1909. She worked at Hull House with Jane Addams and joined the Children's Bureau under Julia Lathrop in 1917, becoming its head in 1921 where she worked to enforce the Sheppard-Towner Maternity and Infancy Act. She was active in the National Consumers League and the Women's Trade Union League after being an active suffragist. Confident that the Children's Bureau was in good hands under Secretary Frances Perkins, Abbott left the Bureau in 1934 to teach in the School of Social Service Administration at the University of Chicago until her death in 1939. Ware, pp.143-4.

MARY ANDERSON

Chief of the Women's Bureau, Department of Labor, 1922-1944. Born in Sweden and emigrating to the United States at sixteen, Mary became an active unionist while working in the garment and shoe industries in Chicago. Naturalized in 1905, she began that year her lifelong association with the Women's Trade Union League. During World War I, Anderson served in the Women in Industry Service. In 1920 she was named director of the newly created Women's Bureau in the Department of Labor where she remained until her retirement in 1944. Ware, p.144.

BARBARA ARMSTRONG

A member from Academia on the Committee on Economic Security which produced the Social Security legislation in 1934-1935. A specialist on social insurance internationally, she was critical of the final Social Security Act, particularly making Unemployment Insurance a federal/state program, rather than a national one. Armstrong earned both a law degree and a PhD in economics and was one of the first women law professors at a major law school, serving as a professor at Boalt Hall at the University of California, Berkeley, from 1935 until her death in 1976. Wikipedia. Downey, 234.

MARION GLASS BANISTER

Assistant Treasurer of the United States, from 1933 to 1951. Daughter of a prominent Virginia family, including Senator Carter Glass and Sweet Briar College president, Meta Glass, Marion married Blair Banister from another old Virginia family. During World War I, Banister wrote publicity for the Committee on Public Information and in the 1920's became active in Democratic Party women's politics, assisting Emily Newell Blair with publicity in the 1924 campaign. She was one of the founders of the Women's National Democratic Club in 1924-5. After being active in the 1932 campaign, President Roosevelt appointed her Assistant Treasurer of the United States where she served until her death in 1951. Ware, p. 144.

CATHERINE KROUSE BAUER (WURSTER)

Executive Secretary of the union-backed Labor Housing Conference. Key advocate for alternative, non-market public housing and lover of Lewis Mumford, Catherine later married prominent Bay Area architect William Wurster after whom UC Berkeley's Wurster Hall is named and in whose library is a bust of Bauer. Her role is explained in a recent article in *The Nation,* "The Way Home: From California to New York, a radical new housing movement is rising, upending the status quo," by Jimmy Tobias, June 18/25, 2018. pp. 22-23.

CLARA MORTENSON BEYER

Associate Director, Division of Labor Standards, Department of Labor, 1934-1957. Born in California to immigrant parents from Denmark, Clara graduated from the University of California, Berkeley, in 1915, earning an M.S. degree in 1916. During World War I she worked on the War Labor Policies Board and the District of Columbia's Minimum Wage Board. While raising her three young sons, Clara became a part-time executive secretary of the National Consumers' League where she formed her lifelong friendships with Frances Perkins and Molly Dewson. She joined the staff of the Children's Bureau in 1928 and from 1931 to 1934 was director of the Industrial Department. In 1934 she became Associate Director of the newly created Division of Labor Standards in the Department of Labor where she remained until her retirement in 1957. Ware, p. 145.

KATHERINE C. BLACKBURN

Director of the Division of Press Intelligence under the National Emergency Council, led by Frank C. Walker, in 1933. Beginning with a staff primarily of women, she helped Walker launch what became known as the United States Information Service, creating such surviving instruments of government communication as the U.S. Government Manual. "A mirror image of the all-male corps of NEC state directors, USIS was entirely staffed by women, including its director [Katherine C. Blackburn]....The New York Times explained this women-only pattern thusly: First, they seem better fitted than men for the kind of work required—patient research, attention to minute details and delving into government documents and so on. Second, at the price he pays, Uncle Sam can get better-qualified women than men. Most of the salaries run from $1,440 to $1,600." The Division of Press Intelligence as a Division of the National Executive Council, played a vital role in early New Deal intelligence gathering and distribution of information about the government throughout the traditional agencies and new divisions, and ultimately out to the public. (The First Presidential Communications Agency: FDR's Office of Government Reports, pp. 21-22)

EMILY NEWELL BLAIR

Assistant to the Chairman of the NRA's Consumers' Advisory Board from 1933 to 1934. Emily was an active suffragist and served on the Women's Committee on National Defense from 1917 to 1918. One of the first women to attain prominence in the Democratic Party, she served as Vice-Chair of the DNC from 1922 to 1928. One of the founders of the Women's National Democratic Club, she was its president in 1928. While active in the 1932 campaign, she rejected an ppointment in the Roosevelt Administration while her husband, Harry Blair, served as Assistant Attorney General. Ware, p. 145.

ALIDA BOWLER

Superintendent of the Bureau of Indian Affairs in Nevada. "The new deal, which put a first woman in the cabinet and a first woman at the head of a diplomatic mission, soon will see another 'first'—the first woman ever named a superintendent of Indian Affairs. Miss Alida Bowler, head of the juvenile delinquency unit of the Children's Bureau, will

be sent to Stewart, Nev., in charge of Indian tribes. It is a combination post in which she will be head of the Carson Indian School and most of the Nevada tribes." (Associated Press, unsourced)

JO COFFIN

Government Printing Office, Assistant to Public Printer, from 1934 to 1941. A copy cutter for the *New York World* from 1916 to 1931, Coffin was active in the International Typographical Union and the New York Women's Trade Union League. In the winter of 1932-1933, between FDR's election and inauguration, she helped Eleanor Roosevelt set up centers for unemployed women in New York City under WTUL auspices. In return, ER lobbied to get Coffin the job at the Government Printing Office which she held until ill health caused her to resign in 1941. Ware, pp. 145-146.

MARJORY STONEMAN DOUGLAS

University of Miami Digital Archive

Journalist, suffragist, conservationist and staunch defender of the Everglades. During the New Deal, she wrote the Foreword to the WPA's guide to Miami and its surrounding area as part of the Federal Writers' Project American Guide Series . Her book, T*he Everglades: River of Grass,* has been compared with Rachel Carson's *Silent Spring* in alerting Floridians to the environmental importance of the Everglades. When she was 103 (she lived to be 108) President Clinton presented her with the Presidential Medal of Freedom and the following citation:

Marjory Stoneman Douglas personifies passionate commitment. Her crusade to preserve and restore the Everglades has enhanced our Nation's respect for our precious environment, reminding all of us of nature's delicate balance. Grateful Americans honor the 'Grandmother of the Glades' by following her splendid example in safeguarding America's beauty and splendor for generations to come.

Recently the nation has rediscovered her through the school named for her, which suffered the massacre in Parkland, Florida, Marjory Stoneman Douglas High School. Wikipedia.

DOROTHY DUNN

An art teacher who had an impact on the lives of many NM Native American would-be artists, many of whom became quite successful. She was the art instructor at the Santa Fe Indian School, virtually a boarding school primarily for teenagers and some young adult students. The program was started by her and was called The Studio School. She taught these young people to portray images they knew from their experiences growing up in their home pueblos and reservations. The images were generally very colorful but flat imaging. Many of her students would receive many awards including one of high esteem from the French government for her and for some of her most outstanding students. Information from Kathryn Flynn.

Dorothy Dunn Kramer

MARTHA MAY ELIOT

Doctor of Medicine, specializing in maternal and child health. Eliot received her M.D. from the Johns Hopkins University School of Medicine in 1918, the same year as her classmate and life partner, Ethel Collins Dunham. Beginning in the new Department of Pediatrics at the Yale Medical School around 1920, Eliot finally became an Associate Clinical Professor at Yale between 1932 and 1935. Starting in 1924, Eliot was simultaneously Director of the Children Bureau's Division of Child and Maternal Health in the Department of Labor, commuting between New Haven,

National Library of Medicine

CT and Washington, D.C. In 1934 she moved full time to Washington when she became Assistant Chief of the Children's Bureau. During WW II she played major roles in securing children's health in both England and the United States. She received the Lasker Award in 1948 for these efforts. She was the first woman president of the American Public Health Association and the first woman to receive the American Public Health Association's Sedgewick Memorial Medal in 1958. Dr. Eliot left the Children's Bureau in 1956 and between 1957 and 1960 served as Chair of the Department of Child and Maternal Health at the Harvard School of Public Health. "Changing the Face of Medicine," US National Library of Medicine, https://cfmedicine.nlm.nih.gov/physicians/biography_99.html.

JANE MARGUERETTA HOEY

NPS.gov

Director of the Bureau of Public Assistance in the Social Security Administration from 1936 to 1953. Born one of nine children in a large Irish Catholic family (her brother Jim was a Tammany political leader), Jane received a B.A. in 1914 and thereafter an M.A. in political science from Columbia University. Her first social work position was under Harry Hopkins on the Board of Child Welfare in New York City from 1916 to 1917. She served as Assistant Director of the Health Division of the Welfare Council of New York City from 1926 to 1936. She then went to Washington and organized the Bureau of Public Assistance within the new Social Security Administration in 1936 and remained until 1953 when she was forced out after the inauguration of Dwight Eisenhower by his Secretary of Health, Education and Welfare, Oveta Culp Hobby, the second woman to serve in a presidential cabinet after Frances Perkins. Ware, p. 147

LUCY SOMERVILLE HOWORTH

Clarion Ledger. /6/1941, newspapers.com

A member of the Veterans Administration Board of Appeal, from 1934 to 1950. Lucy was born in Mississippi in 1895, the daughter of a prominent suffragist, Nellie Nugent Somerville, the first woman elected to the Mississippi legislature. Lucy graduated from Randolph-Macon College in 1916, did graduate work in economics and sociology at Columbia University from 1918 to 1920, and earned her law degree at the University of Mississippi Law School in 1922, one of only two women in her class. During her years in New York City, she visited settlement houses and sweat shops which contributed to her lifelong commitment to the rights of women and minorities. Active in Democratic Party politics in Mississippi in the 1920's, she was elected to the Mississippi legislature for a term lasting from 1932 to 1934. Thereafter she came to Washington in 1934 to serve on the Veterans Administration Board until 1950. From 1949 to 1954 she served as associate general counsel, deputy general counsel and general counsel to the War Claims Commission. Ware, p. 148; Wikipedia.

MINERVA HAMILTON HOYT

Founder of the International Desert Conservation League. Born in Mississippi to a father, Joel George Hamilton, a Mississippi state senator and delegate to the 1872 Democratic Convention, Minerva married a New York doctor and financier, A. Sherman Hoyt, after studying music at conservatories in Cincinnati and Boston. The Hoyts moved to Southern California where Minerva became active in efforts to save the fragile desert ecology, threatened by cars and motorcycles using the Mojave Desert as a motorized playground. The Joshua Trees, a monumental cactus named by the Mormons for the Old Testament prophet, were particularly threatened. Spending time on the desert both in Mexico and California, Minerva took up the cause of the Joshua Trees. For her efforts, the

https://archive.org/stream/anewcyclopedi-47boarrich#page/n15/mode/2up

president of Mexico gave her an honorary doctorate, naming her the "Apostle of the Cacti." Lobbying the new Secretary of the Interior, Harold Ickes, she was able to meet with FDR and persuade him to establish the Joshua Tree National Monument, a huge area between Palm Springs and Twenty Nine Palms. Douglas Brinkley, *Rightful Heritage: Franklin D. Roosevelt and the Land of America* (HarperCollins, 2016), pp. 209-212.

FLORENCE KERR

Appointed as regional director of the WPA Women's and Professional Division with headquarters in Chicago from which she supervised relief work activities in thirteen Midwestern states. Kerr replaced Ellen S. Woodward as WPA assistant administrator for the Women's and Professional Projects (WPP) in 1939. https://www.aaa.si.edu/collections/interviews/oral-history-interview-florence-kerr-11700.

MARY LA DAME

Associate Director of U.S. Employment Services from 1934 to 1938 and Special Assistant to Secretary of Labor Frances Perkins from 1938 to 1945. Graduate of Pembroke College (Brown University) in 1906, Mary La Dame did graduate work at Harvard, Columbia and Carnegie Tech. She did industrial research for the Russell Sage Foundation for nine years and became Associate Director of the Clearing House for Public Employment for New York City from the early 1920's when her friend Frances Perkins brought her into the Labor Department. Ware, p. 148.

KATHARINE FREDRICA LENROOT

Chief of the Children's Bureau, Department of Labor from 1934 to 1949. Daughter of Wisconsin Senator Irvine Lenroot and graduate of the University of Wisconsin in 1912, Katharine began her professional career working for the Industrial Commission of Wisconsin. She became a special investigator for the Children's Bureau in Washington in 1914, became Assistant Chief of the Bureau in 1922 and then took over as Chief of the Children's Bureau when Grace Abbott resigned in 1934, serving until 1949. Ware, p. 148.

BESSIE MARGOLIN

A lawyer for the Department of Labor for 33 years. Reviewing Marlene Trestman's recent book, *Fair Labor Lawyer: The Remarkable Life of New Deal Attorney and Supreme Court Advocate Bessie Margolin* (LSU Press, 2016), Attorney Stephen H. Sachs summarized Margolin's career at the DOL: "That career included her spectacular record in the Supreme Court, where she won 21 of 24 cases she argued; her 33 years in the Department of Labor's solicitor's office where in the words of Chief Justice Earl Warren, her

advocacy developed the 'flesh and sinew' around the 'bare bones' of the Fair Labor Standards Act; and her development, in her final years at DOL, of the strategies that gave life and breadth to the newly enacted Equal Pay Act, a landmark in the struggle for gender equality….Ms. Trestman also notes…that Justice William O. Douglas, who heard every one of Margolin's Supreme Court arguments, wrote that Margolin was among the 'ten best advocates who have appeared before us in the last 25 years that I have been on the bench.'" (*Baltimore Sun*, March 16, 2016).

LUCY MASON

General Secretary of the National Consumers League from 1932 to 1937, succeeding the founder, Florence Kelley. Born into an illustrious Virginia family (she was related to George Mason, John Marshall and Robert E. Lee), Lucy's father Landon Mason was an Episcopal clergyman who passed on his strong belief in social justice for all races. During her five years in New York with the NCL, the only time she lived outside the South, Lucy Mason worked with social workers recruited to staff the New Deal relief and welfare agencies. Mason met and became a life long friend of Eleanor Roosevelt. Developing an expertise in industrial matters with the NCL, Mason became a strong advocate of collective bargaining and John L. Lewis hired her to be the public relations representative in the Southeastern U.S. for the new Council of Industrial Organizations (CIO). For the rest of her life she represented the CIO in a region and in a period of intense hostility toward organized labor. Her genteel, quiet demeanor frequently prevented violence. Eleanor Roosevelt wrote the Foreword to Mason's autobiography, *To Win These Rights*, [1952], noting the "courage" of this "mild looking, soft spoken gentlewoman" with "a fiery fighting spirit." Encyclopedia of Virginia, published by the Virginia Humanities Council, written by John Salmond, https://www.encyclopediavirginia.org/Mason_Lucy_Randolph_1882-1959.

DOROTHY McALISTER

Director of the Women's Division of the Democratic National Committee from 1936 to 1940. Wife of a Michigan Supreme Court judge and graduate of Bryn Mawr, Dorothy McAlister was active in the drives for prohibition repeal and for the Child Labor Amendment. She became state director of the Michigan Democratic State Committee. Molly Dewson brought her to Washington in 1936 as her successor as Director of the Women's Division of the DNC. Dorothy served in that capacity until 1940. From 1947 to 1954, McAlister was Chairman of the Board of the National Consumers League. Ware, pp. 148-149.

Atlantic Constition, 9-14/1933, newspapers.com

LUCILLE FOSTER McMILLIN

Civil Service Commissioner from 1933 to 1949. Born in Tennessee and married to Congressman Benton McMillan, twenty years her senior. Lucille helped him with his career which included serving as Governor of Tennessee and Ambassador to Peru. In the 1920's, she served as National Committeewoman from Tennessee and in 1924 as regional director of Democratic women in the Southern states as well as with the League of Women Voters. Appointment as Civil Service Commissioner in 1933, the year of her husband's death, was both a tribute to him and to her service to the Democratic Party in the South. Ware, p. 149.

EMMA GUFFEY MILLER

Was Committeewoman for the Pennsylvania Democratic National Committee from 1932 to 1970. Graduate of Bryn Mawr in 1899, Emma was active in the suffrage fight. In the 1920's she joined the National Women's Party and ardently supported the Equal Rights Amendment. She seconded the nomination of Al Smith for president at the Democratic Convention in 1924. By 1936 she was Vice-Chairman of the DNC. She held no paid positions during the New Deal, but chaired the Pennsylvania National Youth Administration Advisory Board from 1935 to 1943. Her husband, Carroll Miller, was named to the Interstate Commerce Commission and her brother, a bachelor with whom her family lived, was Senator Joseph Guffey of Pennsylvania. In addition to politics, her main interest was education. Ware, p. 149.

The Sentinel , Pa, 10/20/1937, newspapers.com

JOSEPHINE ASPINWALL ROCHE

LOC

Assistant Secretary of the Treasury from 1934 to 1937. Josephine graduated from Vassar College in 1908 and received her M.A. from Columbia University in 1910 where she became friends with Frances Perkins. From 1924 to 1927 Josephine was Editorial Director of the Children's Bureau. She returned to her native Colorado in 1927 to run the family coal mine where her enlightened approach to labor relations gained her national publicity. She was Denver's first policewoman and faced down efforts by coal mine competitors to drive her family company out of business in a price war. Her mine workers agreed to work at half pay to get the company back on its feet. After Roche's narrow defeat in the Democratic primary for the Senate in 1934, President Roosevelt appointed her Assistant Secretary of the Treasury, making her the second highest ranking woman in the administration after Frances Perkins. In this position she oversaw the United States Public Health Service, which was then part of the Treasury Department. In 1935 she became Chairman of the Executive Committee of the National Youth Administration. Even after retiring from her Treasury position in 1937, she continued as Chair of the Government's Interdepartmental Health Committee into the 1940's. She also served as President of the National Consumers League from 1938 to 1944. Her continuing concern for coal miners led John L. Lewis to urge her appointment as director of the UMW's Welfare and Retirement Fund. In the 1960's she developed a string of hospitals for the UMW pension fund. Ware, pp. 151-152; Robyn Muncy, *Relentless Reformer: Josephine Roche and Progressivism in Twentieth Century America* (Princeton University Press, 2016).

NELLIE TAYLOE ROSS

Director of the United States Mint from 1933 to 1952. Born in Missouri, she spent her adult years in Wyoming and Washington, D.C. Her husband, William Bradford Ross, was Governor of Wyoming. When he died in 1924, Nellie succeeded him in office and was elected governor to a two-year term from 1925-1927. In 1928, she became Vice-Chairman of the DNC and seconded Al Smith's nomination for President at the National Convention. After active and effective service securing women's support in the 1932 campaign, FDR appointed her Director of the U.S. Mint, a position she held until 1952. Ware, pp. 152-153.

Wyoming State Archives

HILDA WORTHINGTON SMITH

Pittsburgh Post Gazette, 10/16/1936, newspapers.com

Director of the Workers' Service Program of FERA /WPA from 1933 to 1943. Hilda was a 1910 graduate of Bryn Mawr and did graduate work at Columbia and the New York School of Social Work. Active in the women's suffrage cause, she returned to Bryn Mawr as a dean and in the 1920's set up the Bryn Mawr Summer School for Industrial Workers. Workers education became her dominant interest. After 1933 her work with the WPA allowed her to pursue this crucial concern nationally. She also was in charge of the FERA/WPA camps and schools for unemployed women from 1934 to 1937. From 1943 to 1945 she worked at the Federal Public Housing Authority before retiring from government service. Ware, p. 154.

SUE SHELDON WHITE

Assistant Chairman of the NRA Consumers Advisory Board from 1934 to 1935. She then served on the Legal staff at the Social Security Administration from 1935 to1943. Born in Tennessee and active in the suffragist fight in her home state from 1913 to 1920, she came to Washington, D.C. in 1920 as a secretary to Senator Kenneth McKellar. She took night classes and received a law degree in 1923, returning to Tennessee to practice

LOC

law and be active in Democratic politics. White became executive assistant to Nellie Tayloe Ross at the Women's Division of the DNC from 1930 to 1933. Her New Deal career included, in addition to the position at the NRA, serving on the National Emergency Council, working under Mary Harriman Rumsey, and on the Social Security Board. By 1938, she was special assistant to the board's general counsel, Jack Tate. Sue White became ill in the early 1940's and died in 1943 at the home she shared with government economist Florence Armstrong. Ware, pp. 154-155.

CAROLYN WOLFE

Director of the Women's Division of the Democratic National Committee from 1934 to 1936. Before marrying Utah Supreme Court Justice James F. Wolfe, Carolyn studied at the University of Chicago. While raising five children in Utah, she became active in the Red Cross, the Parent-Teacher Association and the League of Women Voters. As Vice-Chairman of the Utah State Democratic Committee, Molly Dewson tapped her to be the Director of the Women's Division of the DNC in 1934. Ware, p. 155.

LEADERS IN OTHER RELATED FIELDS

ALICE HAMILTON

While medical doctor Alice Hamilton became a consultant to the U.S. Division of Labor Standards in the Department of Labor during the 1930's, bringing her expertise as a foremost leader in the field of industrial diseases and toxicology, her great contributions came in earlier decades. Born in 1869 to a family of privilege, whose talented children included Edith Hamilton, the great scholar of Ancient Greece and Rome, Alice after her formal medical training became active at Hull House in Chicago where, with Jane Addams, Hamilton was active in women's rights and peace movements, with special interests in civil liberties, birth control and protective labor legislation for women When she accepted the position of Assistant Professor at Harvard in the new Department of Industrial Medicine in 1919 (later the School of Public Health), Alice Hamilton became the first woman faculty member at Harvard in any field. She has been heralded as the pioneering female environmentalist and for her public service contributions became the first female recipient of the Lasker Award in 1947. In 1935, Eleanor Roosevelt presented her with the Chi Omega women's fraternity National Achievement Award. Hamilton died in 1970 at the age of 101. https://cfmedicine.nlm.nih.gov/ physicians/biography_137.html; Wikipedia.

U.S. National Library of Medicine

VIRGINIA GILDERSLEEVE

LOC

Dean of Barnard College. "In 1945, Franklin D. Roosevelt appointed Gildersleeve—the only woman named—to the U.S. delegation to write the United Nations Charter. The group was instructed to address two issues: 1) the need to prevent future wars through the creation of a Security Council; and 2) the need to enhance human welfare, which they accomplished through the establishment of the United Nations Economic and Social Council (ECOSOC). Gildersleeve sought and received drafting responsibility for the work of this second Council—the one, as she put it, in charge of "doing things rather than preventing things from being done." She was able to insert into the Charter the following goals for people around the world: 'higher standards of living, full employment, and conditions of economic and social progress and development.' She also persuaded the delegates to adopt the following aim for the United Nations: 'universal respect for human rights and fundamental freedoms for all without distinction as to race, sex, language, or religion.'

She insisted that the Charter require the appointment of the Commission on Human Rights, which under the direction of Eleanor Roosevelt, wrote the Universal Declaration of Human Rights.' Gildersleeve wrote the opening of the Preamble to the U.N. Charter, changing the draft version that began with the stuffy and top- down words 'The Contracting Parties' to the horizontal emphasis on 'We the peoples of the United Nations …'"which she modeled on that of the U.S. Constitution. Her seminal role is commemorated in a large painting of the U.S. Delegation at San Francisco's Herbst Theatre where the U.N. Charter was signed. She is the only woman in the group portrait." https://www.graduatewomen.org/home-who-we-are/who-was-virginia-gildersleeve; Wikipedia.

ADELINA OTERO-WARREN

Born in 1881 to conservative parents whose lineage traced back to eleventh century Spain, Adelina Otero-Warren was part of the aristocracy in New Mexico. But far from acting like an aristocrat, Adelina's life was spent helping others less fortunate. In 1912 she moved to New York City after a failed marriage to a military man and was active in a settlement house aimed to aid women in the working class. By 1917 she was a leader of the state Congressional Union, later to be called the National Woman's Party, focusing on women's suffrage issues. In 1920 back in NM, she was the chair of the State Board of Health and the Santa Fe Superintendent of Instruction. In 1922 she was the first Latina to run for a seat in the U.S. House of Representative as a Republican but lost. From 1923-1929 she was the Inspector of Indian Schools in Santa Fe and she was designated by President Roosevelt as the NM state head of the federal Civilian Conservation Corps (CCC). She became the Director of Literacy Education for the CCC in New Mexico. Later she worked with the WPA focusing on adult education as well as the CCC. This led her to become the Director of the Work Conference for Adult Teachers in Puerto Rico. She also created a program for Navy sailors, Army soldiers, Air Corps pilots and Marines at Borington Field to familiarize them with the Spanish language. She was a powerhouse wherever she worked. https://americacomesalive.com/2013/09/27/adelina-otero-warren-1881-1965-suffragist; Wikipedia.

SPECIAL WOMEN ASSISTANTS TO FDR

President Roosevelt trusted a significant number of women as friends and close advisors. His appointment of Frances Perkins is a key indicator of this as is the evidence of his great respect for the judgments of both his mother, Sara Delano Roosevelt, and his wife, Eleanor. In addition, two of his top personal assistants were Marguerite "Missy" LeHand and Grace Tully. His distant cousin, Margaret "Daisy" Suckley was, to use the title of Geoffrey Ward's interpretation of their relationship, *FDR's Closest Companion.*

MARGUERITE "MISSY" LEHAND

Missy was the private secretary to FDR, starting as campaign secretary in 1920 during Roosevelt's race for Vice President, and serving him until June, 1941 when the first of a series of strokes sidelined her permanently. Closer perhaps than any other aide to FDR during his long political career (in the same league with Louis Howe), Missy spent time with him from first thing in the morning until he went to bed at night. In many ways she was Chief of Staff, before that position was created and so labeled. The way to see FDR was through Missy. She advised him on people, policies and problems. Through her advocacy, for example, Thomas

"the Cork" Corcoran became a key part of Roosevelt's administration, not only as a shrewd lawyer working with Congress on legislation but also as a key member of the Irish Catholic constituency so crucial to FDR's coalition, a coalition of which Missy herself was a part. Missy was from a modest working class Irish Catholic family in Boston. She served as a key buffer, along with Frank Walker, between two of the most powerful New Dealers, Harold Ickes (PWA) and Harry Hopkins (WPA) in the investment of government money in the New Deal's major public works projects. Missy at last has had a significant biography written about her that recognizes her pivotal role in FDR's first two terms. Kathryn Smith, *The Gatekeeper: Missy LeHand, FDR, and the Untold Story of the Partnership that Defined a Presidency* (Touchstone/ Simon & Schuster, 2016). Upon FDR's death in 1945, it was discovered that he had included Missy in his will to receive half of his estate if she survived him. On her grave stone is the following: MARGUERITE ALICE LEHAND, 1896 to 1944 "SHE WAS UTTERLY SELFLESS IN HER DEVOTION TO DUTY" FDR

MARGARET "DAISY" SUCKLEY

A sixth cousin of Franklin Roosevelt and a neighbor in the Hudson Valley at her nearby family estate, "Wilderstein." They became close friends and at times Daisy spent considerable periods in the White House keeping FDR company. They decided on the desirability of building a cottage for FDR's retirement which they could both enjoy. It is on the porch of Top Cottage, the result of that dream, that Daisy took one of the only photos of FDR in a wheelchair, posed next to a little girl standing beside him. FDR wrote long, newsy letters to Daisy about his experiences when they were apart, providing candid observations about key events and central leaders in World War II, which was rare for FDR to do. Daisy was one of the women with Roosevelt when he died at the Little White House in Warm Springs, GA. After his death she worked at the new FDR Presidential Library and Museum in Hyde Park and played a key role in organizing the archives until 1963 when she retired. She died in 1991 just shy of her 100th birthday. Her story is told in Geoffrey C. Ward's *Closest Companion: The Unknown Story of the Intimate Friendship between Franklin Roosevelt and Margaret Suckley* (Houghton Mifflin, 1995) .

GRACE TULLY

Born in 1890 in Bayonne, New Jersey, Grace Tully received a secretarial education at the Grace Institute in New York. Her first assignment was as secretary to New York Catholic Bishop Patrick Hayes. In 1928 she began working for the DNC, assigned to Eleanor Roosevelt who was assisting Al Smith in his run for president. When FDR was elected Governor of New York that same year, Grace Tully went to Albany to be an assistant to Missy LeHand, FDR's personal secretary. Grace continued in that relationship when Roosevelt was elected president in 1932. She often traveled with FDR to Hyde Park and to Shangri-La (now Camp David) and replaced Missy LeHand after the latter's stroke in June, 1941. Grace Tully was with Roosevelt when he died at Warm Springs, GA on April 12, 1945. She wrote her story, *FDR: My Boss* (Charles Scribner's Sons, 1949); Wikipedia.

New Deal Art Programs
National Project Directors

Forbes Watson papers, 1840-1967, AAA, Smithsonian Institution.

JULIANA REISER FORCE

Director of New York States' PWAP Region 2, including the commuting zone of Connecticut and New Jersey. Juliana was the only woman director of the committee that created the PWAP together with Edward Bruce, Eleanor Roosevelt and George Biddle. With Gertrude Vanderbilt Whitney, Force helped found and direct the original Whitney Museum of American Art in Manhattan, featuring Gertrude Vanderbilt Whitney's own art collection and specializing in modern art from living artists. Force was herself a major collector of both modern art and folk art. In 1942 Juliana Force became chair of the American Art Research Council. https://en.Wikipedia.org/w/index.php?curid=41641349.

EVE ALMANS FULLER

State Archives Florida/Foster

FAP State Director for Florida. Born in Sullivan, Indiana, she was the Editor In Chief for the 1920 Indiana University annual *Ye Arbutus*. She came to Florida in 1921 to write for the *Tampa Bay Times*. Her chief avocation was art and she served as president of the St. Petersburg Art Club and the State Federation. She became the Florida State Director for the WPA/FAP in Jacksonville, resigning in 1943 because of ill health During WW II she served as public information chairman of the local Red Cross. She was state legislative chairman of the League of Women Voters and president of American Penwomen. She helped design the Florida Exhibit at the New York's World Fair in 1939 where she acted as one of the hostesses on Governors' Day. *Tampa Bay Times*, 8/13/1939, pg 6; 8/1/1947,pg 13; 8/20/1947,pg 1.

AUDREY McMAHON

SAAM -6130, Charles Eisenman, photographer

FAP Director of the New York Region, including New Jersey and Connecticut, from 1935 to 1943. The New York FAP employed 5,000 painters, sculptors, graphic and commercial artists, crafts persons and art teachers. She employed 2,139 people, more than a third of those working in the FAP nationally. By May, 1939, 8,742 paintings, 108 murals, 41,787 prints and 1,707 sculptures and architectural works had been created. Born in New York City, she attended the Sorbonne and became director of their College Art Association. In the FAP, she gave artists a great deal of freedom. She later recalled that "It is gratifying to note…that all of the painters, sculptors, graphic artists, and muralists who recall those days remember little or no artistic stricture." As the FAP began its closure in 1939, she worked to delay the liquidation process. It became the Graphic Section of the War Services Division in 1942 in which the mural painters designed and executed camouflage patterns for tanks, ships and other military objects. She resigned in 1943. Oral history interview Audrey McMahon, 1964 Nov. 18. SAAM; Wikipedia.

CHARLOTTE RUSSELL PARTRIDGE

PWAP Wisconsin Chairwoman in 1933-34 and FAP Director in Wisconsin in 1935. Born in Minnesota in 1881. Charlotte Partridge and her life partner, Miriam Frink, founded the Layton School of Art in Milwaukee, Wisconsin in 1920. Partridge was the head of curriculum and instruction and the more public face, while the quieter and more reserved Miriam Frink, who also taught, headed the business side of the school and took

care of any disciplinary issues. During the Great Depression both women made great sacrifices including forgoing their own salaries to keep the school going. Miss Partridge attended the School of the Art Institute of Chicago, the Art Students League in New York, the Emma M. Church School of Art and the Northern Illinois Teachers College. She received the governor's award for "individual support of the arts" and an honorary doctorate in art from Lawrence University. http://www.wisconsinart.org/archives/artist/charlotte-russell-partridge/profile-2578.

PAINTERS

LUCIENNE BLOCH

Born in Geneva, Switzerland, Jan. 5, 1909, to Ernest Bloch. Lucienne came to the United States in 1917. She studied painting in Paris with Andre Lhote. Along with her future husband, Stephan Dimitroff, she worked as an apprentice with Diego Rivera on his murals in Detroit and New York between 1932 and 1934. She was employed by the WPA/FAP in New York from 1935 to 1939 and executed murals in the Women's House of Detention, *Cycle of Women's Life* and the George Washington High School music room, *The Evolution of Music*. In 1939 she completed a mural for the Swiss Pavilion at the World's Fair. In 1942 she was hired by the Treasury Section of Fine Arts (TRAP) to create a mural for the Fort Thomas, Kentucky Post Office. After the Project years, she created twenty murals in public buildings in the U.S. With her husband she became a noted illustrator of children's books. Francis O'Connor, *Art for the Millions: Essays from the 1930's by Artists and Administrators of the WPA Federal Arts Project* (New York Graphic Society Books, 1974}, p. 2.

VERA BOCK

A key person in the FAP Poster Division in New York City, Vera was born in 1902 in St. Petersburg, Russia and died in 2006 at the age of 104 years in Zurich, Switzerland. Her mother, Ida, was a concert pianist and her American father, Paul, an international banker. She learned to read and speak French, German, and English along with Russian. At the time of the Russian Revolution, the family escaped on the last train and eventually settled in New York City. Miss Bock writes of herself: "I drew pictures long before I knew it was Art. I did not make it my career. I used it to earn a living as necessary. It became a career because it happened that enough people liked the way I drew pictures." She returned to Europe to study drawing and painting. In England, she learned wood engraving, illustration and printing in the photo-engraving process. In early 1934, newly elected NYC Mayor Fiorello LaGuardia used FERA funding to institute a program to design posters "pertaining to various city departments." They were civic minded and educational in nature; some were used to promote good health and hygiene. On Feb. 2, 1934 Vera Bock, who was now supporting her widowed mother, qualified for NYC FERA relief employment. She became active in the "Artist Poster Designing Project." The following year, 1935, with the formation of the WPA she was transferred to the NYC/FAP Poster Division. She remained with that division from August 1, 1935 until December 31, 1938, when she left for private employment. A large number of her WPA/FAP/NYC poster designs are in the Library of Congress collection, in addition to her work used in a 1939 WPA/FAP calendar meant to demonstrate the high caliber of art being produced in the FAP projects. Vera Bock became an internationally recognized author, designer and illustrator of books. After the death of her older sister, Margaret, in 1969, Vera married her brother-in-law, Georges Henri Kaestlin, a Russian and Swiss banker. In 1984, following her husband's death, Vera donated The G. H. Kaestlin Zemstvo and Imperial Russian Stamp Collection to the Smithsonian Postal Museum in Washington, D.C. (NASL WPA

employment records, *More Junior Authors.* Muriel Fisher (H.W. Wilson Company Publisher, 1963); Wikipedia. Correspondence between NNDPA Board member, Kathleen Duxbury, and Bock's niece, Alice (Bock) Tischler in 2016. See Poster Art examples.

San Francisco Examiner, 9/25/1963, newspapers.com

Helen, left, Margaret and Ester Bruton.

HELEN, MARGARET AND ESTHER BRUTON

Helen Bruton designed and executed one of the two WPA-sponsored mosaic panels on the exterior of the old University of California powerhouse when it was converted to the University Art Museum. With her artist sisters, Margaret and Esther, the Bruton sisters initially lived in San Francisco and Alameda and did much of their work in the Bay Area. They studied in Paris and painted often in Taos and Nevada. Taking a cue from the building's early Christian architecture, Helen executed her Berkeley mosaic in the Byzantine style with the Brutons' friend, Robert Boardman Howard (son of the building's creator, campus architect John Galen Howard), as a sculptor and likely themselves as the trio of robed women to his right. The sisters also created the mosaics at the Mothers' Building at the largely WPA-built San Francisco Zoo. The Zoo mosaics depict Children and Their Animal Friends and St. Francis. With other women artists such as Florence Alston Swift and Maxine Albro, they led a revival of the ancient art of mosaics in the Bay Area and created an immense sculptural relief for the Court of Pacifica at the 1939-1940 San Francisco World's Fair on Treasure Island, and Helen and Swift did the large mosaic at the University of California-Berkeley. See front cover. (Oral History Interview with Margaret and Helen Bruton, Archives of American Art, 1964, https://www.si.edu/object/AAADCD_oh_213324).

LUCILLE CHABOT

Worked with the WPA/FAP 1939. She created a watercolor of the Archangel Gabriel as a weather vane for the Index of American Design. It was later used in 1965 as a United States postage stamp. Roger G. Kennedy, *When Art Worked: The New Deal, Art, and Democracy* (Rizzoli: New York, 2009), pp. 226-227.

SAAM

MABEL DWIGHT

Studied art at the Hopkins Art School in San Francisco and later settled in Greenwich Village. She worked for the NYC WPA/FAP between 1935-39. Dwight went to Paris and discovered the medium of lithography. After a short marriage to Eugene Higgins, she changed her name to Dwight, a name she apparently made up for herself. Kennedy, p. 180.

ELIZABETH GINNO

Attended Mills College and was influenced by photographer Imogen Cunningham and printmaker Roi Partridge. She continued her studies in art at the California College of Arts and Crafts and the California School of Fine Arts. Ginno worked for the WPA at the Western Museum Laboratory in Berkeley where she created artwork for the National Park Service. She did a series of seventy-five sketches of costumes of various cultures in traditional dress and another series of flower prints as part of "Art in Action" at the 1940 Golden Gate International Exposition on Treasure Island. Her work was exhibited locally and nationally

courtesy Jonh Aronovici

and is in the collection of the Fine Arts Museums of San Francisco. http://www.annexgalleries.com/artists/biography/813/ginno/elizabeth.

Sunday Oregonian, Portland, 6/2/1962, newspapers.com

AIMEE SPENCER GORHAM

One of the few Public Works of Art (PWAP) artists, and one of only three known women who made depictions of the Civilian Civilization Corps (CCC) during this first federally funded art program in 1934. One of her PWAP pen and ink illustrations, CCC Camps in Oregon, was used for the April 1934 cover of *School Life*, an Office of Education publication. As a single mother with two small children, Gorham was appreciative of the PWAP employment opportunity. She wrote the PWAP Director, Edward Bruce: "As one of the artists, I would like to thank you for your great part in the program for the C.W.A. Art projects. It has been splendidly handled and has given encouragement and a great pleasure to all the artists I know who have been employed on it. We have had an opportunity to give our best work and it should have a deep effect. And we are deeply grateful for the helping hand financially."

In 1936, Gorham became a Senior Artist with the newly established WPA Federal Arts Program (FAP) and remained until 1939. She designed a 25 foot wood mosaic mural which was displayed at the New York World's Fair in 1939. In 1943 she was employed as an artist with the U.S. Department of Agriculture and is considered a pioneer in working with architects on art for public spaces, earning the distinction of being named an associate member of the American Institute of Architects. (*Oregonian*, 12/9/1973. p 107; NARA College Park, RG 121, "Records Concerning Federal Art Project, Central Office Correspondence with Artists 1932-1934," E108, Box 2, Folder Go-GZ; WPA Personnel Records, NARA St. Louis; Barry N. Ball, "Artist Aimee Gorham's Rush of Symbolism," *Oregon Cultural Heritage Commission*, 2004).

ZAMA VANESSA HELDER

Artist and teacher with the Washington State WPA/FAP. Vanessa Helder was born in Lynden, Washington and lived in Seattle and Spokane until relocating permanently to Los Angeles in 1943. She studied at the University of Washington and at the Art Students League in New York with Frank Vincent DuMond , George Picken and Robert Brackman. Helder first gained national attention in 1936 when her work was accepted into the American Watercolor Society's exhibition at the National Academy of Design in New York. About 1936, Zama made watercolor and pen and ink illustrations depicting CCC Camp Ginko in Washington. In 1939, Helder joined the staff at the Spokane

courtesy David F. Martin

Arts Center, under the sponsorship of the Washington State WPA, teaching watercolor, oil painting and lithography. While there, she executed a series of Precisionist watercolors depicting the construction of the Grand Coulee Dam and its environs with the approval of the U.S. Bureau of Reclamation. Twelve of her watercolors were included in the "Realists and Magic Realists" exhibition at the Museum of Modern Art in New York in 1943. That same year, she relocated to Los Angeles. Her exhibition history includes the Whitney Museum of American Art, the Metropolitan Museum of Art, the Oakland Art Museum, the Denver Art Museum and the Seattle Art Museum where she had a one-person exhibition in 1939. Vanessa Helder was a member of Women Painters of Washington, the National Association of Women Artists and the American and California Watercolor Societies. David F. Martin, *Austere Beauty: The Art of Z. Vanessa Helder*, Northwest Perspectives Series: Paperback, August 7, 2013, Cascadia Art Museum, Edmonds, WA.

MARY HISTIA

A large pottery jar was made for President Franklin Roosevelt by Mary Histia of Acoma Pueblo, NM inscribed: "Our President Franklin D. Roosevelt" and "U.S. We Do Our Part," 1930s. Histia's main patron was FDR. During the time of his administration until his death, he purchased all of her pottery. It was the aim of the President and Mrs. Roosevelt to see that every U. S. Embassy had a piece of this truly American form. Kennedy, p.36.

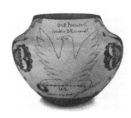

JOSEPHINE HEITT JOY

courtesy Bradley family

Part of the WPA and FAP in California, Josephine Joy exhibited an oil painting, *CCC Camp Balboa,* which depicts a demonstration Civilian Conservation Corps (CCC) camp, at the 1936 San Diego Exposition. She was born in 1869, the youngest of nine children, near Harpers Ferry, West Virginia. The family moved to Peoria, Illinois when she was sixteen and where she made the first of three marriages. and had two children. The last marriage was to Thomas Joy. They moved first to Colorado, then to San Diego, California. Her great grandson, Tobias (Tobe) Bradley, wrote a biographical piece. According to this narrative, in 1927, after the last husband's death, she became interested in art and was virtually a self-taught artist. Joy's first WPA employment began in 1936 when she was 66 years old. She joined the Federal Music Project (FMP) as a singer with the Countywide Music Program for seven months. Her next WPA assignment was as a nurse maid but that may never have happened. She was then assigned work with the Federal Art Project (FAP) as an easel artist until Nov. 1939 when she removed from the project because she had reached the maximum WPA employment periods allowed by law. During that last employment period, Joy attracted national attention at the California Pacific International Exposition in San Diego. There her New Deal art was displayed with the WPA/FAP exhibit. Josephine Joy is one of those rare art personalities known as an authentic primitive. Her work included animals in the San Diego Zoo, bouquets of flowers, and landscapes. Her work was compared to that of the great French primitive artist Henri Rousseau and it was Louis Untermeyer, author, anthologist, editor and poet, who encouraged her to have a one-woman show at the St. Etienne Gallery in New York City in 1943. Josephine explained that "I love to paint in the open sitting in some beautiful garden, hillside or remote place." Today numerous pieces of her FAP art can be found in the Smithsonian American Art Museum (SAAM) collection. Harvey Jones, et. al., *Cat and Ball on a Waterfall: 200 Years of California Folk Painting and Sculpture* (Oakland Museum of Art,1986); https://americanart.si.edu/artist/Josephine-joy-2514; Kathleen Duxbury interview with Tobias Edward Bradley II, great grandson of Josephine Joy, August, 2018.

LEE KRASNER (POLLOCK)

Painted public murals for the Public Works of Art Project (PWAP) and the WPA/FAP in New York City from 1934 to 1943. Born in Brooklyn, the only one of the four children of her Russian Jewish immigrant parents to be born in the U.S., Lee was classically trained in painting but went through repeated changes in styles and genres of painting. Taking classes with Hans Hofmann in 1937 modernized her approach to the nude and still life, developing a cubist style. Her job with the WPA/FAP in the muralist division was to enlarge other artists' designs for large scaled public murals, an ultimately frustrating experience for an artist who was drawn more and more to abstract art. She finally had one of her abstract murals approved as the War began. Henceforth art had to be created for war propaganda. In 1942 she met Jackson Pollack whom she married. She is regarded as an abstract expressionist painter. https://www.theartstory.org/artist-krasner-lee.htm; https://www.biography.com/people/lee-krasner-37447; Wikipedia.

GISELLA LOEFFLER LACHER

Born in Vienna, Austria in 1900, Lacher arrived in New Mexico in 1932 and resided in Taos and Albuquerque. Prior to that, she lived in St. Louis and studied art at Washington University School of Fine Arts. While there she painted a mural on the ceiling of the Children's Hospital. She also studied privately in Gloucester, Massachusetts. Lacher worked in egg tempera, enamel and lacquer. She did various New Deal sponsored art pieces in New Mexico but two outstanding murals were done for the children at Carrie Tingley Children's Hospital in Truth or Consequences, NM. They were later moved to the hospital's new facility in Albuquerque. They are oil and gold leaf on fiber board and one is entitled *Nativity and Ethnic Children* and the other is *Fairy Tale Young Children and Ethnic Children,* both typical of her charmingly playful depiction of folk children of various ethnicities. Some of her other children-related artwork can be found as illustrations in children's books. Collections of her work are in the Museum of Fine Art in Santa Fe, also in Los Angeles and in a large collection at the Panhandle-Plains Museum in Canyon, Texas. Lacher died in 1969. Kathryn Flynn, *Public Art and Architecture in New Mexico*, 1933-43 (Sunstone Press, 2012).

AIDA McKENZIE

Senior Artist of the FAP, Poster Division in New York City from February 6, 1935 to May 1939. Among her assignments were cover illustrations for the FWP's *Almanac for New Yorkers,* numerous posters and artistic services for the Metropolitan Museum of Art. NARA St. Louis employment records; LOC poster collection.

DOROTHY LAVERNE MERIDETH

1932, W. Division High School, Milwaukee, WI, ancestry.com

Merideth was born in Milwaukee, Wisconsin November 17, 1906. She became an artist with the PWAP /WPAin Milwaukee. A graduate of the Layton School of Art, she held degrees from Cranbrook Academy of Art and Wisconsin State Teachers College. During her work with the PWAP she depicted, in watercolor, the CCC working at Sheridan Park in Milwaukee. At least fifteen of her PWAP landscapes and watercolor still life's were allocated to various Milwaukee schools, colleges and government offices in Washington, D.C. After working with the PWAP, Dorothy traveled extensively to study art and the fiber arts in Europe, Japan and China. She was an award winning professor of weaving in the Department of Fine Arts at the University of Wisconsin. She was a member of the Wisconsin Watercolor Society, the Wisconsin Painters & Sculptors, the Wisconsin Designers Club (president), and the Walrus Club. Merideth was in a number of solo exhibitions including the Milwaukee Art Institute; Layton Art Gallery; Grinnell College, Grinnell, Iowa; and the Wustum Museum, Racine, Wisconsin. Charlotte Partridge and Miriam Frink Papers 1862-1980, UW-Milwaukee Archives, Layton School of Art, Dorothy Meredith.

ALICE NEEL

Alice Neel was one of the first artists to work for the WPA/FAP. In her realist style, her subjects included Depression-era street scenes and Communist thinkers and leaders. Her many portraits captured her subjects from a psychological standpoint. In her portraits of female nudes and also of male nudes, she transformed ways in which the human form was presented. https://moore.edu/alumni/stories/alice-neel.

Lynn Gilbert 1976, NY

MINÉ OKUBO

Interpreted Diego Rivera's mural at the San Francisco World's Fair in 1940. Born in California in 1912, Mine' Okubo received a Master's in Fine Arts from the University of California at Berkeley in 1938. Thereafter she spent two years in France and Italy, studying with Fernand Leger. On her return she collaborated with Diego Rivera and his murals for the WPA in San Francisco. She created mosaics for Fort Ord and for the Servicemen's Hospitality House in Oakland before being incarcerated at Tanforan with other Japanese

Americans after Japan's attack on Pearl Harbor. After six months, she and her brother were transferred to Topaz Relocation Camp in Utah. She sketched constantly, recording images of drama, humiliation and everyday struggle. A small number of her drawings were included in *Fortune Magazine's* April, 1944 special issue on Japan. After the War she moved to New York City and in 1946 published a memoir, *Citizen 13660*, documenting her internment camp experience. *Weekly Biography*. https://www.womenshistory.org/education-resources/biographies/mine-okubo

EMMY LOU PACKARD

Chief Assistant for Diego Rivera's Pan American Mural at the San Francisco's World Fair in 1940. Emmy Lou was born in El Centro, California in 1914. Her father, an internationally known agronomist, moved the family to Mexico to consult with the Mexican government on agrarian and land reform. Thirteen year old Emmy Lou was already painting when her mother introduced her to Diego Rivera and Frida Kahlo, beginning a long friendship and mentorship. When Emmy Lou's young husband was killed in a car crash in 1939, Emmy Lou went back to Mexico and lived with Rivera and Kahlo. When Rivera came to San Francisco to work for the Golden Gate International Exposition in 1940, he asked Emmy Lou to be his chief assistant for the Pan American Unity mural. She later designed and executed two murals in Lower Sproul Student Union Center at the University of California at Berkeley. The one at the Chavez Student Center is a five-foot high bas relief modernist mural depicting California landscape features. Wikipedia.

DOROTHY PUCCINELLI and HELEN FORBES

Painted murals for the interior of the Mothers' Building at the San Francisco Zoo. Puccinelli and Forbes used egg tempera to paint a four-panel mural illustrating Noah and His Ark—the Waters Subsiding and Renewal in 1938 with Federal Arts Project (FAP) funds on the interior of the 1925 Mothers' Building, a refuge for mothers and their children near the original entrance to the San Francisco Zoo. They painted the work from inspiration found while sketching animals in the zoo. Richard Rothman, who has worked to restore the building and the murals, observed that "Most of the artists during this time were men. At Coit Tower, there were 23 artists, and only five were women. At the Mothers' Building, [the murals] were all done by women."

RUTH REEVES and ROMANA JAVITZ

The founders of the *Index of American Design* were Ruth Reeves, a textile designer, and Romana Javitz, head of the Picture Collection at the NY Public Library who convinced Holger Cahill, the Director of the WPA/FAP, to engage Constance Rourke, a cultural historian and folklorist and Adolph Cook Glasgold, a designer, to supervise her work. The *Index* operated in thirty-four states and the District of Columbia.

Ruth Reeves

EDITH O. RENAUD

Part of the PWAP Region No. 6 in New Orleans, Louisana and one of the few women assigned to depict the CCC, previously called the Emergency Conservation Works (ECW). Renaud's watercolor titled *E.C.W. Camp* was allocated to Mr. George Berry, Room 4861, Commerce Building in Washington, D.C. NACP-RG121-E112.

LALA EVE RIVOL

As an artist and member of the San Francisco bohemian set centered on North Beach's Montgomery Block, Rivol persuaded local WPA Arts Administrator, Joseph Danysh, to permit her to copy Indian rock art in remote sites in California, Nevada and Arizona for the *Index of American Design*. Because weathering and vandalism have severely degraded or erased Rivol's subjects, her lithographs of petroglyphs are today invaluable resources for scholars of prehistoric Indian cultures and for ancestors of the creators. Fine Arts Museum of San Francisco.

FLORENCE ALSTON SWIFT

courtesy Swift family

Born in San Francisco in 1890, Florence Alston Swift studied at the Mark Hopkins Art Institute (later the San Francisco Art Institute) and continued at the Art Students League in NYC and the Hans Hofmann School of Art. She exhibited in New York and Philadelphia. In 1920, she married Henry Swift. She studied mosaic technique in Venice and Ravenna. During the 1930's she worked for the Federal Arts Project and exhibited her prize-winning art throughout the Bay Area, including the mosaic at the University of California-Berkeley 9which is on the front cover of this book0 and also at the Golden Gate International Exhibition in 1939. A resident of Berkeley until 1962, she died in nearby Orinda in 1977. Edan Hughes, *Artists in California, 1786-1940*; *American Art Annual 1919-1924*; *Who's Who in American Art 1938-1962*.

PABLITA VELARDE

courtesy Pablita Velarde family

Born in the Santa Clara Pueblo near Espanola, New Mexico, Pablita was educated at two schools for Native Americans in Santa Fe, St. Catherine's Indian School and the Dorothy Dunn Santa Fe Studio Art School. A childhood eye disease caused temporary loss of sight and she noted, "Temporary darkness made me want to see everything and so I trained myself to remember, to the smallest detail everything I saw when my sight returned." As a young woman, she traveled all over the country with the Ernest Thomson Seton family caring for their child. Upon returning to her pueblo, she learned to make her paints from pigments taken from rocks and minerals. In 1939, the WPA/FAP commissioned her to depict scenes of traditional pueblo life for nearby Bandelier National Monument. Sharing such images of the pueblo life got her in serious trouble with her tribal elders but she was just thrilled that the money provided her the opportunity to build her own adobe home in the pueblo while raising her two young children. That artwork is still in the monument's art collection. She did other New Deal art that can be found at the Museum of Indian Art in Santa Fe. Later she created a large sand painting in the New Mexico State Capitol and a large mural at the Pueblo Cultural Center in Albuquerque, NM. In her later years, she became famous for her Native American dolls which she created with clothing and jewelry typical of various native pueblos. Before her death, she shared native folk tales from her childhood with her illustrations in a book titled, *Old Father Storyteller*. Velarde joined Maria Martinez as the two most accomplished Native American women artists of their generation. Both Velarde's daughter, Helen Hardin, and granddaughter, Margarete Bagshaw, also became popular artists before their early deaths. The picture of Pablita was taken at the 1938 Santa Fe Fiesta as provided with permission from her great-granddaughter, Helen Tindel, also an artist. The picture of Pablita was taken at the 1938 Santa Fe Fiesta as provided with permission from her great-granddaughter, Helen Tindel, also an artist. Flynn, pp. 322-324.

The Women Who Painted Coit Tower

Women artists were among the group of artists that painted the first major mural project of the New Deal in Coit Tower, San Francisco. They are representative of the thousands of women who would participate in New Deal art programs. Like their male counterparts, they painted both in the genre of the American Scene and Social Realism and some ventured into Abstraction. The Coit Tower murals were done under the Public Works of Art Project (PWAP), the first New Deal program to employ artists. It was short lived, lasting only six months, but when it ended in June 1934, it had employed 3,749 artists. The popularity and success of the Coit Tower project inspired the many New Deal arts programs that followed. (The following summaries are from an article by Jon Golinger reprinted in the *Living New Deal Newsletter*, Winter 2017.)

Oakland Tribune, 1/5/1934, newspapers.com

MAXINE ALBRO

Painter, muralist and lithographer, Albro was born in Iowa and came to San Francisco in 1920 to study at the California School of Fine Arts. She later traveled to Mexico, met Diego Rivera, and studied fresco. In her Coit Tower mural, *California*, she included the New Deal's National Recovery Administration (NRA) logo on boxes of oranges being packed by workers in the field. The model for one of the mural's field hands was another Coit Tower artist, Parker Hall. Soon after the Coit Project was completed, Albro and Hall married, moved to Carmel and joined the Carmel art colony.

JANE BERLANDINA

Born in France, Berlandina was brought up in luxury. She was entranced by art and earned a degree from the exclusive Beaux Arts National School of Nice where her teacher was post-impressionist Raoul Dufy whose style is quite different from that of Diego Rivera, the mentor of other Coit Tower artists. Berlindina's mural, *Home Life*, is set apart in a small room on the tower's second floor. Her use of egg tempera—pigments mixed with egg yolks as a binder—gives her transparent, seemingly unfinished figures a light touch that contrasts with scenes of Depression-era street life and labor strife depicted in the tower's other murals.

Cumberland Evening Times, 5/24/1932, newspapers.com

San Francisco Examiner, 4/5/1936, newspapers.com

EDITH HAMLIN

Born in Oakland, California, Hamlin was assigned to paint outdoor recreation on the tower's second floor where elevator doors would be smack dab in the middle of her mural. She made the most of it with her fresco *Hunting in California*, which depicts a hunting dog at the ready, a duck hunter with his prize, wild geese flying free, and a deer grazing. Hamlin went on to work for the Federal Arts Project, painting two enormous murals at San Francisco's Mission High School. She later married painter Maynard Dixon at whose San Francisco studio a group of artists had earlier gathered to insist that the government provide work for starving artists—a demand that led to the Coit Tower murals.

SUZANNE SCHEUER

Moving to San Francisco from San Jose in 1918, Scheuer studied at the California School of Fine Arts and the California College of Arts and Crafts. When Scheuer was assigned to paint a Coit Tower mural depicting newspaper production, she was initially reluctant to take on the job. She went to the Chronicle Building, did sketches of the offices and printing plant, and turned them into one of the liveliest of the Coit Tower murals, *Newspaper Gathering*. After the Coit Tower project, Scheuer went on to paint post office murals in Berkeley, California and in Caldwell and Eastland. Texas. She later moved to Santa Cruz, where she designed and built six houses, doing much of the labor herself.

SCULPTORS

LULU HAWKINS BRAGHETTA

Graduate of the University of Nevada, Lulu Braghetta earned an M.A. degree from UC Berkeley. She had further art training in New York City at the Art Students League, the Metropolitan School of Art, and the Grand Central Art School. Returning to California in 1932, she studied at the Chouinard School of Art and became a professional sculptor with a studio in San Francisco. She contributed wall reliefs on Treasure Island for the Golden Gate International Exposition in 1939. She did wooden bas-relief panels for the Yuba City Post Office and exterior cast stone panels on the west side of Berkeley High School. She taught at California College of Arts and Crafts and at Vallejo Junior College. Edan Hughes, *Artists in California 1786-1940* (Crookes Art Museum: Sacramento, 2009). Wikipedia.

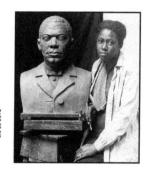

SAAM

SELMA HORTENSE BURKE

A "people's sculptor," and member of the Harlem Renaissance movement working with Augusta Savage at the Harlem Community Arts Center. In addition to sculpted portraits of famous African Americans, her portrait honoring FDR was the basis for his profile on the Roosevelt Dime. https://www.blackpast.org/african-american-history/burke-selma-hortense-1900-1995; Wikipedia.

MARIA POVEKA MONTOYA MARTINEZ

Harold Agnew collection

A Native American potter, born in 1887, at the San Ildefonso Pueblo in New Mexico near Santa Fe, Maria learned pottery by watching her aunt, grandmother and cousin as they made their pottery and by age eleven she began creating her own pottery. She and her sister, Desideria, were chosen by the Pueblo Council to attend St. Catherine's Indian School in Santa Fe for two year and then finished her schooling at the pueblo with a government teacher. She married at 17 to Julian Martinez and they left that day for the 1903 World's Fair in St. Louis which was to be the first of four World Fairs they attended as potters and dancers. Traditional pottery making techniques were being lost and early on she was determined to try different techniques to help preserve this early cultural art. Needless to say, she achieved her goal and most likely became the best known Native American potter in our country and in the world. Her husband also became famous for the painting of her pottery. The Director of both the Museum of NM and the School of American Research, Dr. Edgar L. Hewitt, was interested in preserving the black on-black pottery of earlier Pueblo peoples and learned of Matinez who was working to perfect this type of pottery and sought her out in 1907 to carry out his desired goal. Together with the Martinez couple, they achieved their combined goals and in the meantime, the couple had four sons and also raised her baby sister who was deaf. For seventy years, Maria, first with her husband and then son, Popovi Da, created for her people and this nation, pottery that would become extremely valuable. The couple was involved in New Deal Native American art programs and she taught many pottery classes for the youth in her pueblo and other sites. She received numerous honorary doctorates ---the last when she was 94 just prior to her death. Other awards and decorations from various countries are too numerous to mention. Kathryn Flynn, *Public Art and Architecture in New Mexico, 1933-43* (Sunstone Press, 2012), pp. 282-284.

LOUISE NEVELSON

National Portrait Gallery, SAAM

Born in Kiev, Russia and brought to the United States in 1905, Louise Nevelson was raised in Rockland, Maine. She moved to New York in 1920 after her marriage and began to study voice. In 1929 she began to work at the Arts Students' League with Kenneth Hayes Miller, and was able to go to Munich in 1931 to study with Hans Hofmann. She worked as an assistant to Diego Rivera in New York from 1932 to 1933. In 1935 she was employed by the WPA/FAP Easel Division in New York and also taught sculpture. She had her first one-woman show of sculpture at the Nierendorf Gallery in 1941 and the following year another one-woman show of etchings at the Lotte Jacobi Gallery. In 1967 the Whitney Museum presented a retrospective of her work and her work can be found in most major museum collections. Francis O'Connor, *Art for the Millions,* (NY Graphic Society, LTD, 1973).

AUGUSTA CHRISTINE FELLS SAVAGE

Born in Florida where she learned to sculpt with clay, Augusta moved to New York City in 1920 and enrolled at Cooper Union. Based on her sculptures of W.E.B. Du Bois and Marcus Garvey, and of a street urchin, she received a Julius Rosenwald Fellowship to study in Paris from 1929 to 1931. Teaching art in Harlem, in 1934 she became the first African American elected to the National Association of Women Painters and Sculptors. In 1937, under the auspices of the WPA/FAP, she became the first director of the Harlem Community Art Center which played a crucial role in the development of many young black artists. Her piece, *The Harp,* was commissioned for the 1939 World's Fair and was inspired by James Weldon Johnson's "Lift Every Voice and Sing." Unfortunately it was not cast in durable materials and was lost along with many other of her works. https://www.biography.com/people/augusta-savage-40495; Wikipedia.

NARA

CONCETTA SCARAVALIONE

SAAM

Born in New York City the youngest of nine children of Calabrian immigrant parents, Concetta attended the tuition-free National Academy of Design and ultimately the Arts Student League where she studied with John Sloan, Stirling Calder, William Zorach and Boardman Robinson. Throughout her teaching career (Black Mountain College, Sarah Lawrence College, Vassar College), she took breaks for time in Europe. In 1926 she was elected to the New York Society of Women Artists. She was hired by the WPA/FAP and became one of twelve sculptors chosen to receive a commission for the Treasury Section of Painting and Sculpture. She made four works for the government, *Railway Man –1863* in aluminum now in the William Jefferson Clinton Federal Building; *Agriculture,* a limestone relief at the Federal Trade Commission; *Woman with Mountain Sheep,* a large plaster figure at the Federal Building for the New York World's Fair in 1939; and *Aborigines,* a limestone relief for the Drexel Hill Post Office in Pennsylvania. In 1937 she joined the Architects, Painters, and Sculptors Collaborative, mostly made up of other Federal Arts Project artists who were encouraged to create works for public housing, sewage structures, hospitals and other public facilities. The Guild held their own show in 1938 with 39,000 visitors in attendance. Scaravaglione entered her sculpture, *Girl with Gazelle,* which received recognition on the covers of both *Newsweek* and *Art Digest.* americanart.si.edu/artist/concetta-scaravaglione-4284; Wikipedia.

FEDERAL MUSIC PROJECT

Photo by Herbert Mitchell, NY.

ANTONIA BRICO

A pioneering woman conductor and pianist, Brico grew up in the Bay Area and graduated from UC Berkeley in 1923. She conducted major European and American orchestras despite widespread resistance to her entering what had traditionally been a male-dominated field. Like other artists, she found employment during the Depression scarce. Nonetheless, in 1934 she founded the Women's Symphony Orchestra. Five years later on the admission of men, it became the Brico Symphony Orchestra. Under the auspices of the WPA Federal Music Project, she conducted the Federal Symphony Orchestra to packed houses. *New York Times* obituary, August 18, 1989; Wikipedia.

SIDNEY ROBERTSON COWELL

LOC- N.Y. World Telegram collection

A WPA project manager from 1938 to 1940 for a project to form a representative collection of folk music being actively performed in Northern California. The project was the result of a joint effort of the WPA, the Library of Congress and the Music Division of the University of California at Berkeley. Hoping to develop a prototype that could be employed around the country, Cowell built a collection of living folk musical traditions found in Northern California during the late 1930's and 1940's in a wide variety of musical styles, including folk music of immigrants arriving from the turn of the century through the 1920's, American popular songs current from 1900 through 1940, as well as old California songs from the Gold Rush Era and before, old medicine show tunes, San Francisco Barbary Coast songs and ragtime. She graduated from Stanford University in 1924 and studied piano in Paris with Alfred Corot at the Ecole Normale de Musique. Later in New York she directed the music program at the Henry Street Settlement on the Lower East Side and in 1936 became an assistant to Charles Seeger, technical advisor to the Music Unit of the Special Skills Development of the Resettlement Administration in Washington, D.C. (later the Farm Security Administration). It was in this setting that Sidney began collecting recordings of folk music in Appalachia and the Ozarks and the Upper Midwest before applying these interests to Northern California. https://web.archive.org/web/20170407053824/http://csumc.wisc.edu/src/collector.htm.Wikipedia.

A. P. Schmidt Collection, Music Division, LOC

MABEL DANIELS

A major composer, Mabel Daniels in 1935 put Edwin Arlington Robinson's poem, "The Song of Jael" to music for orchestra, chorus and soprano solo. The *Boston Post* critic called it "a prolonged hymn of triumph that comes to a mighty climax….This by no means conventional piece makes a valuable contribution to American choral music." Madeline Gross, *Modern Music Makers: Contemporary American Composers* (E.P. Dutton, 1952).

GRACE FALKE TUGWELL

Served as the liaison between the National Youth Adminstration's art projects and the Joint Committee on Folk Arts of the WPA/FMP, under Charles Seeger (Pete's father), John A. Lomax and Benjamin Botkin, as they rediscovered a legacy of music which included the dozen folk songs recorded by Zora Neale Hurston. Roger G. Kennedy, *When Art Worked: The New Deal, Art, and Democracy* (Rizzoli: New York, 2009).

Honolulu Advisor, 1/24/1938,

FLORENCE BEATRICE PRICE

The Plain Dealer, 8/11/1939, newspapers.com

The first African-American woman to achieve national recognition for her accomplishments as both a symphonic composer and pianist. Her Symphony in E Minor won the Wanamaker Prize in 1932 and was performed in 1933 by the Chicago Symphony Orchestra, making it the first work composed by an African-American woman to be played by a major symphony orchestra. She created more than 300 compositions and was inducted into the American Society of Composers, Authors and Publishers in 1940. Her "Songs to the Dark Virgin" was performed by Marian Anderson. Price was invited by Eleanor Roosevelt to visit her in the White House. https://www.biography.com/people/florence-beatrice-price-21120681; Wikipedia.

HELEN CHANDLER RYAN

NNDPA collection

A native of Illinois, born in 1891, Helen Chandler came to Silver City, NM in 1915 as the Head of the Music and Art Department at the NM Normal School, now NM Western University. In 1917 she married District Judge Raymond R. Ryan and they moved to Albuquerque where he practiced law. The couple had three sons and one served on the board of the NM Chapter of the National New Deal Preservation Association from its beginning until his death. With the creation of the WPA's Federal Music Project in 1935, Helen C. Ryan became the New Mexico FMP Director, providing employment for jobless musicians around the state. They provided music instruction and entertainment in schools, colleges, correctional facilities, CCC and NYA camps but particularly in the rural areas of the state. New Mexico FMP participants also identified and recorded NM's indigenous folk music from its three dominate cultures which was somewhat unique since other state FMP programs focused primarily on creating and funding symphonic orchestras and concerts since that was the goal of the National FMP Director, Nicolai Sokolov. NM already had a symphony that was carrying out that cultural mission. Following the closure of New Deal programs, Ryan administered a Civil Defense program from 1941-44 and then became the director of the UNM Harwood Foundation until the mid-1950s. Before her death in 1981, she served on many boards focusing on the arts, music and education. *Spanish American Music in New Mexico: The WPA Era.* (New Mexico FMP Project: Unit 1-5, 1936-37).

RUTH CRAWFORD SEEGER

http://meakultura.pl/edukatornia/kobieca-strona-muzyki-czesc-vii-xx-wiek-102

Training as a pianist at an early age, Ruth Crawford, after enrolling at the American Conservatory of Music in Chicago in 1921, redirected her career to music composition. Crawford's compositions were not the acceptable parlor song and lullabies. Her creations were considered experimental or 'ultra-modern' music, a realm primarily occupied by male composers. Undeterred, she became the first woman to win two prestigious Guggenheim Fellowships, allowing her to work in Paris and Berlin. She completed her important work, *The String Quartet*, upon her return home and married her then harmony teacher, Charles Seeger. She is frequently considered the most significant American female composer in the twentieth century. In 1936 the Seegers moved to Washington, D.C. and she was employed by the WPA's Federal Music Project. During this time she composed less contemporary music and turned to organized research on American musical cultures. She had collaborated with poet Carl Sandburg on folk song arrangements in the 1920's, and hen with the famous folk-song collectors John and Alan Lomax in the 1930's, she emerged as a central figure in the American music revival, issuing several important books

of transcriptions and arrangements and pioneering the use of American folk songs in children's music education. At the same time, she helped raise Seeger's three children from his first marriage, including Pete Seeger with whom in subsequent decades she worked aggressively for social change. She and Charles had four children of their own including Peggy Seeger, another folk musician in the family. Only in 1952, the year before she died, did she return to working with modernist musical material. Kendra Leonard, *The Innovations of Ruth Crawford Seeger*; Judith Tick, *Ruth Crawford Seeger: A Composer's Search for American Music* (Oxford Press, 2000), p. 212; : Elie Hisama, *Gendering Musical Modernism: the Music of Ruth Crawford, Marian Bauer and Miriam Gideon* (Cambridge University Press, 2006), p. 4.

FEDERAL THEATER PROJECT

Stage magazine from December 1940, Vol. 1, Number 2 (page 78)

HALLIE FLANAGAN

"It did seem, during the early months of FDR's second term [1937], that Hallie and the Federal Theatre Project were basking in the glow of a benevolent star. Everyone knew that painful cuts and layoffs were coming, but for a time they were kept at bay. Hallie was able to report, in the Federal Theatre Bulletin early that year, that twelve thousand people were working in 158 theatres in twenty-eight states, playing to weekly audiences totaling five hundred thousand….Most gratifying, for Hallie, was the increasingly high quality of the work itself. 'The people of the Federal Theatre,' she told her national staff proudly when they gathered that March in Washington, 'have put across against tremendous odds, working within a governmental machine (the inflexibility of which can scarcely be imagined), working against a tide of public opinion which in the beginning was almost universally scornful, snobbish, contemptuous—these people have put across a program unparalleled in its audacity, originality and scope.' " Susan Quinn, *Furious Improvisation: How the WPA and a Cast of Thousands Made High Art out of Desperate Times* (Walker & Company, 2008), p. 141.

HELEN TAMIRIS

A professionally trained dancer, Tamiris became chief choreographer of the NYC FTP and promoted racial integration on stage. Her works dealt with social issues like racism and war. Her suite of dances called *Negro Spirituals*, created between 1928 and 1942, protested against the discrimination experienced by African Americans. *How Long Brethren?*, a production of the WPA Federal Dance Project (part of the FTP), was danced to African American protest songs. She was one of the first choreographers to use jazz and spiritual music to explore social themes via dance. *Encyclopedia Britannica*, https://www.britannica.com/biography/Helen-Tamiris.

The Daily News, 4/1/1942, newspapers.com

FEDERAL WRITERS PROJECT

GRACE HAYWARD GATTS

Actress and Playwright, Grace was commissioned by the FTP to write the play, *CCC Murder Mystery*, which was reputedly performed more than 1,000 times. In an effort to expand the audience range, Grace adapted the script making it suitable for schools and correctional institutions. A versatile and accomplished young amateur actress, Grace Hayward became a professional before she was 20. Born in 1868 in Terre Haute, Ind., Hayward ran away from home at age 13 to join a medicine show, and was engrossed in the theater ever after. During the 1890s she performed with "Ferris Comedians," a traveling troupe, and eventually married Richard Ferris, the head of the company. Ferris promoted her for a time as "The Grace Hayward Company." In about 1901 she put together her own stock company of 15 actors, traveling what was then known as the Kerosene Circuit (they lugged along their own kerosene lanterns for footlights). The company, with Hayward directing and playing all the leading roles, was such a hit that it regularly sold out the massive 1,500-seat Warrington. She was an active suffragette, raising money to benefit the work of such pioneering feminists as Ernest Hemingway's mother Grace Hall Hemingway. After she and Ferris divorced, she married George Mahan Gatts, a Chicago theater mogul, who was 15 years her junior. During the Twenties and Thirties, Hayward and Gatts toured the country presenting many of her original plays. By 1940, the Gatts had retired to Los Angeles. George died on April 8, 1949, and Grace died January 7, 1959 at age 90. H. Lee Murphy, "Kick Up Your Heels, Recalls Legendary Oak Park Resident", *Chicago Tribune,* July 13, 1990; http://articles.chicagotribune.com/1990-07-13/entertainment/9002270180_1_oak-park-theater-george-m-cohan; https://www.imdb.com/name/nm1334220/bio.

ZORA NEALE HURSTON

"Out of the Federal Writers Project…several persons who having begun toward the so-called end of the [Harlem] Renaissance seemed to flourish in the darkest days of the Depression. One of them, Zora Neale Hurston, effectively bridged the gap between what may be described as the first and second stages of the Renaissance. This young anthropologist, a student of Franz Boas at Columbia, began to write short stories in the late twenties and collected a mass of folk lore in the United States and the Caribbean area on which many of her later works were to be based. In rapid succession she wrote novels, collected short stories, issued scholarly pieces on folklore, and wrote authoritatively on Haiti and Jamaica. Between 1931 and 1943 she published *Moses, Man of the Mountain; Jonah's Gourd Vine; Mules and Men; Their Eyes Were Watching God; Tell My Horse; and Dust Tracks on a Road.* Certainly with such works as Miss Hurston produced one could hardly say that the Renaissance was over." John Hope Franklin, F*rom Slavery to Freedom: A History of Negro Americans* (Third Edition, A Vintage Giant, 1966), p. 513. Recently her very first book, a 117 page manuscript titled *Barracoon*, was published for the first time. "It told the true story of Cudjo Lewis, an Alabama man who was believed to be the last living person captured in Africa and brought to America on a slave ship." In her *New York Times* review, Alexandra Alter suggests the book's release "could have a profound impact on Hurston's literary legacy." *New York Times*, May 1, 2018.

courtesy Grand Rapids Public Library

CONSTANCE MAYFIELD ROURKE

Born in Cleveland, Ohio in 1885, Rourke received her BA from Vassar College in 1907. With a grant from the Borden Fund for Foreign Travel and Study she was able to study at the Sorbonne in 1908-1909 and the next year did independent study in Paris and London at two major museums. Returning to the United States, she taught English at Vassar from 1910 to 1915 and as a free-lance writer specialized in American folklore and humor. Her article on Paul Bunyan in the July 4, 1918 *New Republic* was the first published on that subject. From 1935-36 she was editor of *The Index of American Design* with WPA/FAP Director Holger Cahill. In 1938 she published *Charles Sheeler: Artist in the American Tradition.* Her classic work was *American Humor* (1931) which had a significant impact on the study of popular and folk culture. http://hilobrow.com/2011/11/14/constance-rourke; Wikipedia.

DOROTHY WEST

Winning second place behind Zora Neale Hurston in the National Urban League Writing Contest for her story, *The Typewriter*, West was a shrewd observer of African-American communities. Her stories, written with support from the WPA/FWP, led to two major novels in later yars. *The Wedding* (1995), was published with the encouragement of Jacqueline Kennedy Onassis. https://www.britannica.com/biography/Dorothy-West.

Dayton Daily News, 5/23/1948, newspapers.com

CIVILIAN CONSERVATION CORPS (CCC)

NACCCA Journal

MILDRED VALANDRY-BLANCHE

Only known woman CCC Enrollee, although a number of women served in other supportive roles, Valandry-Blanche provided the following personal account:

How could a woman begin a career in the Depression Years of the 1930s? It happened to me via the CCC – Indian Division, providing a stepping stone for my federal career of 34 years. Winnebago, Nebraska, my home town, had little to offer adults much less a high school senior. There was, however, a U.S. Indian agency on the outskirts of town which provided various services to the Winnebago Indian population. I first served as a volunteer for 6 months, then was offered a paying job at the Indian agency as an enrollee in the CCC Indian Division at a salary of $45 per month. I was paid this larger amount because the agency did not provide accommodations for lodging or subsistence. The work was confined to building bridges, roads, earthen dams, shelter belts and recreation areas. My first duty of the day was to be at the warehouse to hand out all necessary equipment for the day's work. Later I was involved in doing clerical record-keeping, and promoted to position of Leader at a monthly salary of $60. In September of 1938, I left the CCC to attend business college in Sioux City, Iowa. Upon graduation, I received a position with the Bureau of Indian Affairs at Fort Totten, North Dakota. Here I was associated with the CCC Indian Division and worked with the Sioux Indians. It was a distinct compliment when they referred to me as "Ohan Wanahca," which means "White Flower." I went from picks, nails and shovels, to a personnel career. National Assoc. of CCC Alumni Journal, 1983, Vol.6

NATIONAL PARK SERVICE (NPS)

ELIZABETH (YELM) KINGMAN

One of the first women employed by the National Park Service. From 1937 - 1939, after graduating from the University of Denver with a double major in Anthropology and French, she was a Mesa Verde National park ranger and later museum assistant. There she met and married New Deal artist, Eugene Kingman, who created three Post Office murals.

FARM SECURITY ADMINISTRATION (FSA) PHOTOGRAPHERS

BERENICE ABBOTT

A photography student of Man Ray in Paris in the 1920's, Berenice Abbott brought her artistic vision to New York City where her ambitious project to photograph the architecture and neighborhoods mirrored what Eugene Atget had done for Paris. In 1935 the FAP funded her to manage her "Changing New York " project with major staff assistance. By the time she resigned from the FAP in 1939, she had produced 305 photographs, primarily sociological studies embedded with modernist aesthetic practices, capturing the diverse people of NYC, the places they lived, worked and played in, and their daily activities. Her ideas were influenced by Lewis Mumford. Wikipedia.

The Pantagraph, 5/22/1932, newspapers.com

DOROTHEA LANGE

Born Dorothea Margaretta Nutzhorn in 1895 in Hoboken, New Jersey to second-generation German immigrants. She dropped her father's family name after he abandoned them when she was twelve and assumed her mother's maiden name, Lange. She contracted polio at age seven, leaving her with a permanent weakened right leg and a limp. "It formed me, guided me, instructed me, helped me and humiliated me," Lange once said of her altered "gait". Upon graduating from Wadleigh High School for Girls she was determined to go into photography and went to Columbia University and apprenticed in several photography studios. Leaving New York in 1918, she and a female friend were stranded in San

Francisco after being robbed. She became a photo finisher in a photo supply shop in San Francisco. While there she met an investor who aided her in establishing a successful portrait studio catering to rich socialites. She married artist Maynard Dixon and they had two sons. With the onset of the Great Depression, she turned her camera to capturing the unemployed, homeless people on the streets, This captured the attention of Roy Stryker in FDR's Federal Resettlement Administration (RA), later to be called the Farm Security Administration (FSA). She worked together in these agencies with her second husband, Paul S. Taylor, an economics professor at UC Berkeley to document rural poverty and the exploitation of sharecroppers and migrant laborers. Lange's poignant FSA images became icons of the Depression era, particularly her well known *Migrant Mother*. After Pearl Harbor, she was hired by the War Relocation Authority to document the forced evacuation of Japanese Americans from the West Coast. After the War, she accepted a faculty position at the California School of Fine Arts and co-founded *Aperture*, a leading photographic magazine, while also working for *Life Magazine*. One of her grandchildren has carried on her grandmother's legacy with her own film documentary work and was one of the conference speakers. *Dorothea Lange: Grab A Hunk of Lightning*: A Dyanna Taylor, American Masters on line. https://www.britannica.com/biography/Dorothea-Lange; Wikipedia.

MARION POST WOLCOTT

Ralph Steiner and Paul Strand, having seen Marion Post's work, recommended her strongly to Roy Stryker, head of the Farm Security Administration (FSA) photography project. From the mid 1930's to 1942 she did photographs for the FSA exploring political aspects of poverty and deprivation, not without a sense of humor. Wikipedia.

JOURNALISTS

ANITA BRENNER

Art critic evaluating WPA art in New York, Anita Brenner influenced George Biddle who urged FDR to establish the Federal Arts Program. Born in Mexico to immigrant Jewish parents from Latvia, Brenner grew up in both Mexico and Texas and became a major voice in interpreting Mexico and its art and artists both in Mexico and the United States. http://remezcla.com/features/culture/anita-brenner-mexico-skirball/; Wikipedia.

LORENA HICKOK

A top woman journalist, Lorena Hickok became Eleanor Roosevelt's key communications advisor and best personal friend in the early years of the New Deal. "ER achieved her first notable White House success on March 6, [1933] with her press conference for women journalists only: 'I was a little nervous at first, but the girls were so nice and so friendly that I got over it quickly.' The press conferences were Hick's idea: they would establish understanding and support for the First Lady's activities, and they would ensure jobs for women in Depression-weary newspapers and wire services. Both FDR and Louis Howe had agreed with Hick's suggestion and encouraged ER to do it. That night, ER called Hick to report on the conference. Thirty-five journalists had met in the Red Room, 'and there weren't enough chairs, so some of them had to sit on the floor.' Male reporters made much of this, and wrote nasty commentary about docile newshens sitting at ER's feet. But ER enjoyed herself: 'It really wasn't bad. I think I'll continue with them.'" And, with the kind of competitive glee that had been part of her life since she made the first team at field hockey as a student at Allenwood, she concluded: 'I really beat Franklin. He isn't holding his first press conference until Wednesday.'" Cook, pp. 40-41. Also, Susan Quinn, *Eleanor and Hick: The Love Affair That Shaped a First Lady* (Penguin Press, 2016).

MARY FULLER McCHESNEY

Art historian and sculptor now living in Petaluma, California, Mary grew up during the Depression. Her student days were at the University of California, Berkeley previous to WW II and the incarceration of Japanese-Americans. While at Berkeley she worked with the National Youth Administration (NYA). During the War she worked as a welder in the shipyards and considered that her introduction to sculpture. She was introduced to the art community in San Francisco through the cooperative Artists' Guild Gallery. She also was a potter at California Faience. McChesney associated with the Abstract Expressionists at the California School of Fine Arts in the 1940's. She wrote fiction and had some success as a mystery writer. She performed an invaluable service for scholars by interviewing many New Deal artists for the Archives of American Art's oral history project, documenting the WPA art projects in California. Her first significant publication was on the San Francisco School of Abstract Expressionism, *A Period of Exploration*. She and her husband, Robert McChesney, a WPA artist, built their home in the hills above Petaluma, CA. https://www.aaa.si.edu/collections/interviews/oral-history-interview-mary-fuller-mcchesney-12498; Wikipedia.

ANNE O'HARE McCORMICK

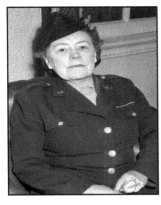

Born in England and raised in Massachusetts, McCormack (husband Francis McCormack) became an international journalist reporting for the *New York Times*. She shared her perspectives on the rise of fascism in Europe with President Roosevelt. She had face to face interviews with Mussolini, Hitler, Stalin, Churchill, Pope Pius XI and Pope Pius XII, as well as with FDR. She received a Pulitzer Prize for her reporting in 1937. In 1946 she was selected to represent the U.S. as a member of the first delegation to the UNESCO conference at the U.N. Wikipedia.

DOROTHY THOMPSON

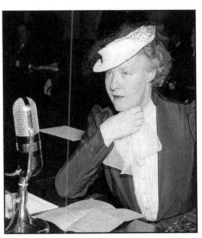

In 1939, *TIME*, with Dorothy Thompson on its cover, named her the second most popular and influential woman in the country behind Eleanor Roosevelt. A journalist in Europe during the 1920's and 1930's, where she became head of the Berlin bureau for the *New York Post*, she witnessed and reported on the rise of Hitler and the Nazis. She interviewed Hitler in Munich in 1931 and wrote a book, *I Saw Hitler,* which described Hitler as a "little man." She was expelled from Germany in 1934, the first foreign journalist to be kicked out by the Nazi regime. Thompson became a radio correspondent for NBC in the late 1930's. She had been one of the earliest voices to inform FDR of Hitler's threat to Europe. In 1935 she reflected on the possibility of a Hitler coming to power in America, a theme her husband Sinclair Lewis developed in his novel, *It Can't Happen Here.*

No people ever recognize their dictator in advance. He never stands for election on the platform of dictatorship. He always represents himself as the instrument [of] the incorporated National Will.... When our dictator turns up, you can depend on it that he will be one of the boys, and he will stand for everything traditionally American. And nobody will ever say 'Heil' to him, nor will they call him 'Fuhrer' or 'Duce' (Mussolini's title). But they will greet him with one great big, universal, democratic, sheeplike bleat of 'Okay, Chief!'"

Dorothy Thompson (1935)

Helen Thomas, *Watchdogs of Democracy? The Waning Washington Press Corps and How It Has Failed the Public* (New York: Scribner, 2006), pp. 171- 172; https://www.biography.com/people/dorothy-thompson-9506148.

ADDITIONAL WOMEN AND THEIR JOB TITLES

These additional names do not constitute a complete list of all the women who worked in a New Deal program in some capacity. We hope the reader will review this list and if you have information on any of these women or others yet to be identified, we would be most pleased to receive it. Please contact Kathy Flynn by email at newdeal@cybermesa.com or mail to P. O. Box 602, Santa Fe, NM 87504.

WOMEN LEADERS IN GOVERNMENT, POLITICS and the LAW

Fanny Brandeis	WPA	Kentucky State Director
Ethel J. Edwards	WPA	Connecticut State Director
Harle Jervis	WPA	California State Director
Margaret Klem	WPA	Field Representative, Professional and Service Division
Lee Van Puymbroeck	PWAP	Portland, Oregon Director
Jerome Sage	WPA	Mississippi State Director (reportedly a woman)

WPA's HISTORICAL RECORDS SURVEYS (HRS)

Eva Carnes	HRS	1935	State Director-West Virginia
Anne K. Gregorie	HRS	1935	State Director-South Carolina
Sylvia Schlafer	HRS	1937	Massachusetts Portrait Survey

SUPPORTIVE ROLES STAFF

Mabel S. Brodie	HRS	1938	Nat. Office, Editor-Public Records Unit
Dorothy Cline	WPA	1937	Training Consultant to Recreation Section
Agnes Cronin	WPA	1936	Administrative Asst.-Women's and Professional Division
Elizabeth Edwards	HRS	1936	Nat. Office, Editor-Federal Archives Inventory
Clara Bechtel Holbrook	CCC	1933	Confidential Assistant and Executive Secretary to Director
Margaret Elliot	HRS	1937	National Office Staff
Margaret Stephenson	WPA	1939	Special Asst.- Div. of Professional and Service Projects
Dr. Louise Stanley	DOA	1923	Director , Bureau Chief, Division of Home Economics
Edythe Weiner	HRS	1936	Nat. Office, Editor-County Archives Unit

WPA'S FEDERAL ART PROJECT (FAP) NATIONAL DIRECTORS and STAFF

Mary Curran	FAP	1935	Field Supervisor
Mildred Holzhauer	FAP	1935	Exhibition Management
Mary Monsell	FAP	1935	Nat. Information Officer
Ruth Reeves	FAP	1935	Nat. Coordinator-Index of American Design

STATE FAP DIRECTORS

Charlotte G. Cooper	FAP	1935	State Director-Ohio

Increase Robinson (Josephine Dorothea Reichmann) FAP IL. State Director 1935-38

WPA'S FEDERAL MUSIC PROJECT (FMP)--SUPPORTIVE STAFF

Louise Ayres Garnett	FMP		Also a poet, playwright, composer, musician and author
Dorothy Fredenhagen	FMP	1935	Nat. FMP office staff (also PWAP earlier)
Margaret Kerr	FMP	1937	Nat. FMP office staff
Alma Sandra Munsell	FMP	1935	Nat. FMP office staff (also PWAP earlier)
Ruth Haller Ottaway	FMP	1935	Nat. FMP administrative staff (also PWAP earlier)

WPA'S FEDERAL THEATER PROJECT (FTP) DIRECTORS

Muriel Brown	FTP	1936	Teacher of theater at CCC camp(s) California
Rosamond Gilder	FTP	1935	Director- Bureau of Research and Publications
Shirley Graham	FTP	1936	Director-Negro Unit in Chicago; Wife of African-American sociologist, Dr. W.E.B. Du Bois.
Rose McClendon	FTP	1935	Co-Director-Negro Theater Project-New York
Helen Schoeni	FTP	1935	Assistant Regional Director

STATE FTP DIRECTORS

Dana Doten	FTP	1935	State Director—Ohio

WPA'S FEDERAL WRITERS PROJECT (FWP) DIRECTORS and STAFF

Claire Laning	FWP	1938	Assistant Director-National Office
Katherine Kellock	FWP	1936	Nat. Office, Editor-Tours Section
Dora Thea Hettwer	FWP	1935	Exec. Secretary to National Director

OTHER FWP STATE DIRECTORS

Ina S. Cassidy	FWP	1935	State Director-New Mexico
Grace Stone Choates	FWP	1935	Assistant Director-Montana
Irene Fuhlbruegge	FWP	1936	State Director-New Jersey
Muriel Hawk	FWP	1937	State Director-Massachusetts
Alice P. Henderson	FWP	1938	State Director-New Mexico
Geraldine Parker	FWP	1935	State Director-Missouri
Ethel Schlasinger	FWP	1935	State Director-North Dakota
Elizabeth Sheehan	FWP	1935	State Director-Nebraska
Agnes Wright Spring	FWP	1938	State Director-Wyoming
Mabel S. Ulrich	FWP	1935	State Director-Minnesota
Dorris May Westall	FWP	1936	State Director-Maine

NATIONAL YOUTH ADMINISTRATION (NYA)

Dorothy Deschweintz	NYA	Director Division of Educational Camps. Previously with U.S. Employment Service, Department of Labor
Anne Treadwell	NYA	California State Director

Multiple sources are responsible for names included in this "List of Additional Women" among them are *Pick Axe and Pencil: References for the Study of the WPA*, Maxine D. Bloxom, 1982, https://digital.library. unt.edu/ark:/67531/metadc6387, also Bibliography Section: General Reading Rooms Division, Library of Congress 1982.

Glossary

Acronyms for federal repositories, organizations and references used in this book.

Federal Repositories

 NARA - National Archives and Records Administration

 NACP - National Archives at College Park, Maryland

 NADC - National Archives at District of Columbia, Washington, D.C.

 NASL - National Archives at St. Louis, St. Louis, Missouri

 AAA - Archives of American Art, Smithsonian Institution, www. aaa.si.edu

 DOL - Department of Labor, dol.gov

 FDRL – Franklin Delano Roosevelt Presidential Library – Hyde Park, New York

 LOC – Library of Congress – Prints and Photographs - http://www.loc.gov/pictures

 NPS – United States National Park Service

 SAAM – Smithsonian American Art Museum, https://americanart.si.edu/

 SSA – Social Security Administration History, https://www.ssa.gov/history/

New Deal Organizations/Partners

National New Deal Preservation Association	www.newdeallegacy.org
Living New Deal	www.livingnewdeal.org
Frances Perkins Center	www.francesperkinscenter.org
FDR Presidential Library	www.fdrlibrary.org
FDR Foundation	www.fdrsuite.org
Roosevelt House	www.roosevelthouse.hunter.cuny.edu
Roosevelt Institute	www.roosevelt.insitute.org
Center for New Deal Studies	www.roosevelt.edu/newdeal
CCC Legacy	www.ccclegacy.org
Greenbelt, Maryland	www.greenbeltmd.gov
Greendale, Wisconsin	www.greendale.org
Greenhills, Ohio	www.greenhillsohio.us
Roosevelt, NJ	www.rooseveltnj.org
Aberdeen, VA	nwi9054658@aol.com
FDR Four Freedoms Park	www.fdrfourfreedomspark.org
Roosevelt Institute for American Studies	www.roosevelt.nl
Save the Post Office	savethepostoffice.com
Eleanor Roosevelt National Historic Site	www.nps.gov/elro/index.htm
Home of FDR National Historic Site	www.nps.gov/hofr/index.htm
Roosevelt Campobello International Park	www.fdr.net
FDR Memorial	www.nps.gov/frde/index.htm

INDEX

CPSIA information can be obtained
at www.ICGtesting.com
Printed in the USA
LVHW071030090619
620624LV00026B/362/P

9 780578 437